STREET RENEGADES

New Underground Art

Francesca Gavin

Laurence King Publishing

LAURENCE KING

© text 2007 Francesca Gavin
Published in 2007 by Laurence King Publishing Ltd.

361–373 City Road
London EC1V 1LR
United Kingdom
Tel: + 44 20 7841 6900
Fax: + 44 20 7841 6910
e-mail: enquiries@laurenceking.co.uk
www.laurenceking.co.uk

A catalogue record for this book is available
from the British Library.

ISBN-13: 978 1 85669 529 9

Design by Peter Richardson
Printed in Singapore

STREET
RENE~~GADES~~

CONTENTS

Introduction

Someone is leaving potatoes around the city. Painted root vegetables stuck with colourful toothpicks are sitting on top of bus shelters that lead into East London. No one knows who puts them there or what statement they are making. Instead they create a silent trajectory across the city, which only observant people sitting on the top of double-decker buses see. There's an art element to the work of Mr Potato—to give the artist a fictional name. The colours of the pieces vary in their fluorescent painted combinations. These little anonymous interventions are not profit-based. Nor do they appear to be publicizing the artist. Instead, they merely change the way people experience city life.

In the period leading up to the millennium, there was an explosion of graphic two-dimensional street art. International cities were brimming with stencils, stickers and wheat-pasted posters influenced by graffiti's focus on identity and the ubiquity of commercialism. Street art became a counterbalance to commercial advertising and its assault on consumers. Yet it became increasingly hard to stand out from this flood of art imagery, which was moving even faster thanks to the Internet. The work began to feel stale and hollow. Its methods were too quickly absorbed and well used by the mechanics of branding. It had a crisis of authenticity. Many of the artists creating two-dimensional work wanted to push things in different directions. In a way, these wall pieces did not go far enough to disrupt urban experience, to force people's attention away from the normal experience.

A new wave of artists has developed—artists who are reinventing art on city streets. Some are coming out of the street-art and graffiti scenes; others have a fine-art background, but want to experiment with public space. Most of the artists in this book are exhibiting in galleries as well as creating illegal street pieces. What makes their work so interesting is how it operates between "fine" art and "street" art to form something else. They use the space and methods of street art, but focus on the importance of the idea in creating work. These are renegades, deserting both the frustrations and commodification of the art world, and the aesthetics and rigidity of graffiti.

This new wave of work is fresh, partly because it uses different techniques and materials—including children's toys, chalk, vinyl, perspex and mosaic tiles. Much of this new work is sculptural and three-dimensional. Often the work is literally manipulating urban architecture and interacting with the street furniture itself. Sometimes the work is about adding something to the streetscape rather than defacing or destroying it. The definition of vandalism blurs. Other artists, using traditional techniques like paint and posters, are pushing things into more innovative territory in their imagery and approach. Narrative and myth is built around the work, as it widens out to transform the aesthetics of the streetscape in different ways.

Many of the artists, no matter what their background, are reflecting the influence of the Situationists and Guy Debord. Much of the work directly responds to

Debord's ideas of the spectacle. Defining "the spectacle" is no easy task. The spectacle is society itself, is part of society and the instrument to dominate society. Mass media is only one aspect of it. It is about the success of economy and the law and about all other facets of life, including human life. Its first prerequisite is passivity and it aims to isolate the individual. Reality itself becomes replaced by images of it. As Debord wrote, "There can be no freedom apart from activity, and within the spectacle all is banned." Most art itself is, therefore, just part of the spectacle. The Situationists called for the creation of situations that unified art and life outside this framework. They fought to move beyond art as it was—governed by the spectacle.

One of the methods they suggested to reinvent art was "detournement". This process was inspired by Dadaist collage and involved a technique where elements of an original were reassembled into a new creation, such as taking ads or mass-media symbols and modifying or reinforcing the meaning of the original image or objects. It's a theory that defines the current post-millennial wave of street interruptions. Many artists are taking advertising and pop-culture imagery and literally cutting it up, reassembling it and reforming it in different ways. If the spectacle is summed up by non-intervention, then this art consciously intervenes. It is active, not passive.

The reason why this work is so important culturally is because it forces the public to become aware of and interact with the world around them. In a culture dominated by a glut of sensationalist, vacuous, throwaway media and virtual culture, the "real" physical world has to reassert its presence in our lives. People have to reconnect with the awareness of other people in our fragmented societies. The only place where individuals literally come into contact with each other is outside the bubble of their homes, screens, commodities. The street is the only place where we know something is real—not exaggerated or interpreted. Free public interventions rebel against submissive consumption. They are, by definition, forms of subversive protest.

Pigeonholing this work as a "youth" movement is redundant—especially as most of the artists are well into their thirties. It is a way of trivializing the spark within the art. Although some of the work is Political with a capital P, it is impossible to create pieces that are illegal without some sense of politics. As the artist Influenza explains, "Anything we do to express our own individual opinions, ideals and findings is political by definition." It is part of the reason that so much of the language of war has been used in connection with graffiti over the years—bombing, guerrilla art, tagging. In a world where everyone is transformed into a passive consumer, creation can be a potentially revolutionary alternative. As the artist Joseph Beuys said, "To make people free is the aim of art, therefore art for me is the science of freedom."

CALIPER BOY

The world of Caliper Boy is innately mysterious. The character and artwork connected to him resemble the pages of a Victorian "penny dreadful". Gothick, atmospheric and disturbing. The work varies from murderous texts painted in scrawled type on city walls to strange wheat-pasted posters depicting poison bottles or an odd little boy with a full body brace and a hand in his pants.

The myth-like project grew out of an afternoon in the miserable drinking dens of Soho, London. The artist and instigator of the project began conversations with his drunken literary collaborator. "We wrote this story about this foul-mouthed and rather uncouth child from the weird and horrible parallel world of Scumdon," he explains. "Some time later we stumbled upon an image of a boy with this contraption fixed to his head. We re-drew it, added some bits and basically ripped it off, as it fitted the story so well. Being a screen printer of sorts I thought it would make quite a nice poster." Other aspects to the project are odd gothick installations in abandoned buildings or urban nooks and crannies. Caliper Boy's bedroom, for example, was created in an abandoned squat with disintegrating walls and ageing grime. Here fiction steps into reality.

The artwork surrounding the story of the strange character is only part of the project. The myth of the character is as important as the ephemera that built it. Caliper Boy's world is a strange space of its own running parallel to contemporary reality. As the artist notes, "We both share an interest in folklore and witchcraft. By putting up our posters we are resurrecting the legend and myth of Caliper Boy and his uncomfortable past." The story itself revolved around a "foul-tongued, sour-faced and sort of Piggy-eyed" child imprisoned in a damp basement of a Soho bordello by his prostitute mother, who saw him as her dirty little secret. The boy was given a brace for his "contorted and bent spine, like the withered roots of an old oak tree" and was later absorbed by an underworld of thieves and rogues. The pickpocket-cum-rent boy writes his name around the streets of his city pointing out another side to the city. A bit like a graffiti version of Jack the Ripper, the character refuses to be ignored.

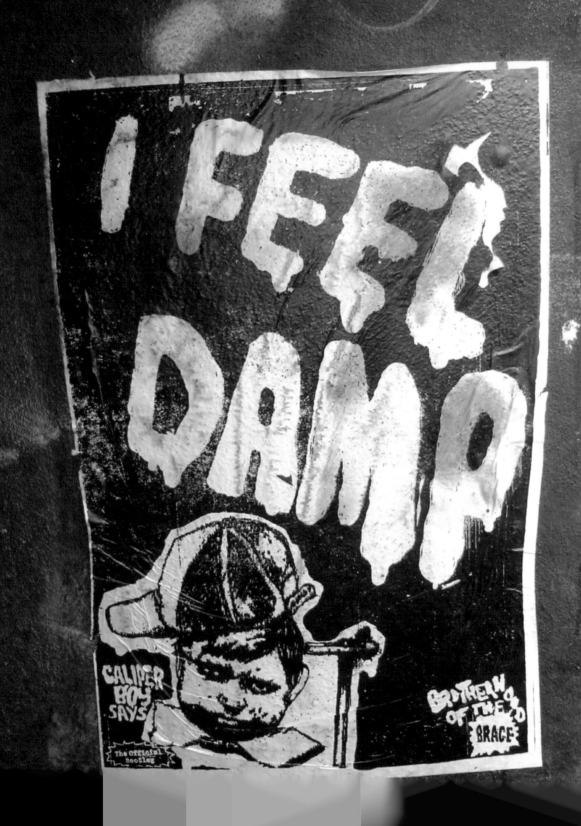

Page 9:
Shoreditch, London, 1853.

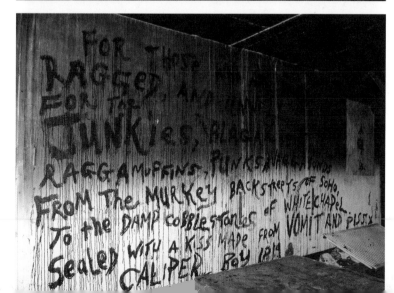

Left:
Whereabouts unknown,
London, 1859.

Right:
Whitechapel, London, 1850;
Whitechapel, London, 1848;
Whitechapel, London, 1848.

CUT UP

London's CutUp specializes in urban disruption. The members of the group came together out of a shared desire to comment on the urban environment. "We want to draw attention to the psychological environment that we all inhabit and how the controlled visual elements of the city can directly affect how people feel and think," they keenly point out. Their work uses existing materials on the street without adding anything new. Instead, they take materials such as billboards and advertising posters and manipulate and reorder them to comment on their role in space. Initially this involved tearing down ads, cutting them into mosaic squares and pasting them together to form new collage images. They transformed billboards and bus-stop advertisements into pixel-like portraits of youths and marginalized characters in society. "We felt that they symbolized the isolation and disaffection of society," they observe, quoting Guy Debord: "His actions are no longer his own but rather someone that represents them to him."

In more recent pieces, they have pushed their techniques, drilling holes in wooden slabs against lightboxes or lit bus stops that work in a similar way to their collage pieces. Here light rather than tone creates their images. Their gallery pieces play with the same approach as their street work—from installing bus stops in gallery spaces to making films that rearrange television ads in the same way as street posters. "More recently our work has used images of buildings and architecture, as well as scenes of destruction or violence that imply chaos or disorder. These buildings inactively personify the feelings of alienation, in much the same way as the city is used as protagonist in Scorcese's *Taxi Driver*."

Their influences float between the experiential and the intellectual. Between scaffold wraps, boarded-up shops, shipping containers, industrial plants, broken streetlights and patterns in everyday life, to thinkers and artists like Walter Benjamin, the Situationists, Dada, Dieter Roth, William Gibson and Slavoj Zizek. Their art walks the boundaries between invention and annihilation. "As one of our group said, 'Things like driving round the M25 for 24 hours and drilling thousands of holes in a wooden box and then burning it SHOULD be done simply because we can.' The same applies to destruction—because you can."

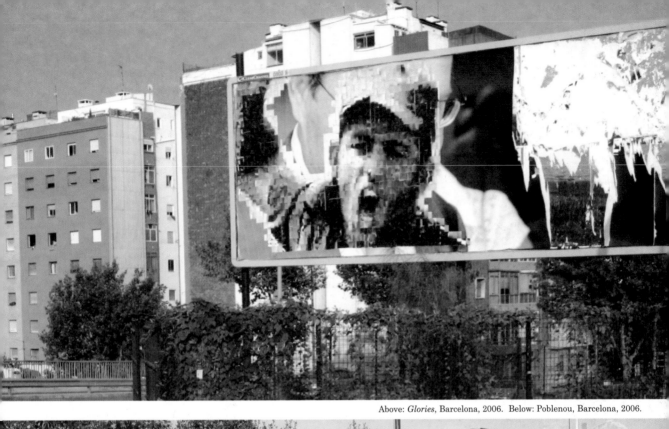

Above: *Glories*, Barcelona, 2006. Below: Poblenou, Barcelona, 2006.

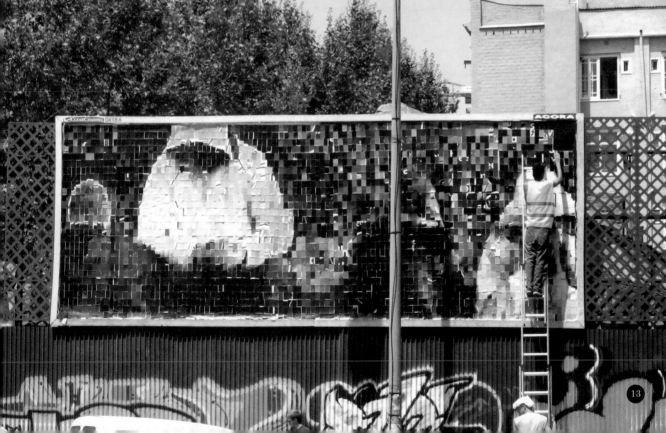

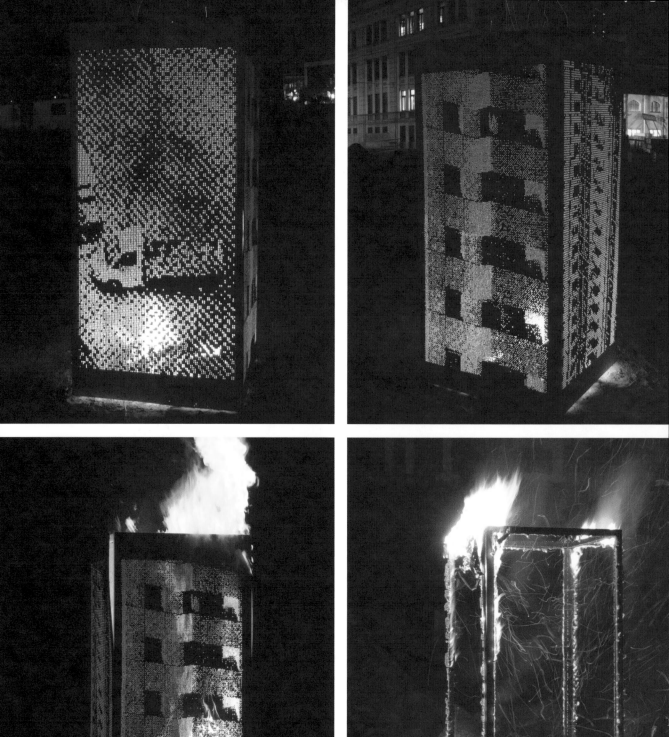

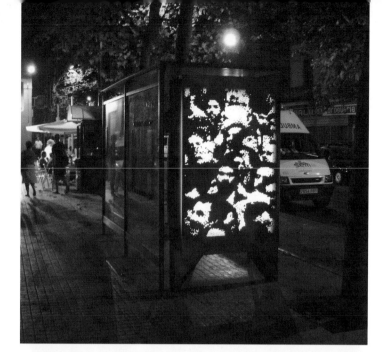

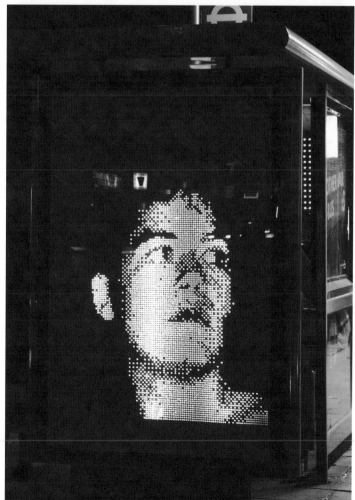

Left:
Live in the Ruins, London, 2006.

Right:
Poblenou, Barcelona, 2006;
London, 2006.

BRAD DOWNEY

City dwellers have become so accustomed to the minutiae of public architecture that its presence fades away and becomes invisible. Brad Downey's work forces us to become aware of the street signs, pedestrian crossings and objects that swamp city streets. "Construction workers are invisible because they are a diversion of the normal flow of traffic. They are not questioned because they are working for the city," Downey explains. "I feel the same about the street objects and control devices. They are not questioned because they are working for the city. They are the visual manifestations of the rules or the truth. I feel it is the artist's job to question the fundamental truths of their culture."

His work exaggerates, distorts and humanizes urban space. A miniature sign is installed in the concrete next to a larger one and called *Madonna and Child*. The glowing bollards on a traffic crossing are repeated so that six yellow balls balance on the one original. What appears to be normal is twisted to show its innate ideological strangeness. "The city is a completely human world that desperately tries to shut out all other forms of life. Everything is designed. Even nature gets designed into the fabric of the city layout," he points out.

Downey considers skateboarding to be his first street installation. "My skateboard taught me how to be creative with my surroundings and question the fundamental function of things," he recalls. "A bench is no longer a bench—it becomes an obstacle for self-expression." Brad first started installing work outside in 1998, collaborating with graffiti artist Verbs aka Darius Jones. Downey's background in fine art (he studied at the Slade School of Art in London) fused with Darius's focus on illegality and urban space. The pair would install paintings in unexpected places. Instead of a "No Parking" sign they would install a colourful drawing. Their street installations became more complex and subtly playful. It was around this time that he also created the influential street art documentary film "Public Discourse", which re-examined how the public perceived street art and interventions. The film informed a lot of critics about the vital nature of street art. "I believe everyone needs and benefits from creative acts," Downey enthuses. "Everyone needs to question his or her surroundings and reality."

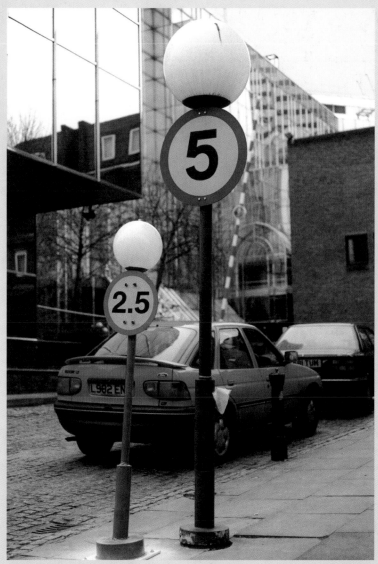

Madonna and Child, London, 2004.

Endless Column in Context, London, 2005.

Hit and Run, London, 2005.
Dead, London, 2005.

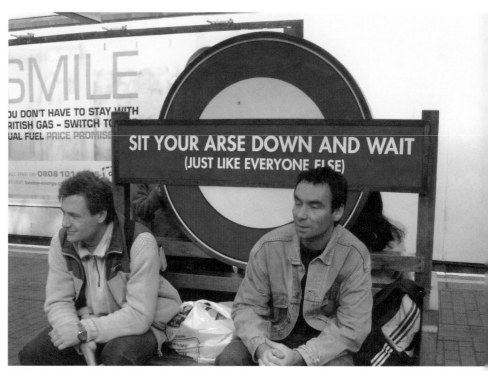

Sit Your Arse Down (a collaboration with Darius Jones), London, 2004.

Father's Duty, London, 2004.

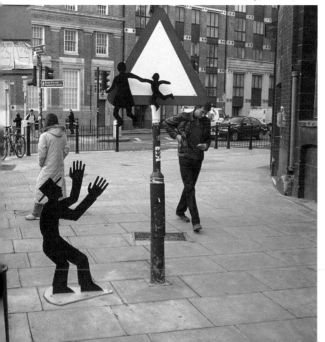

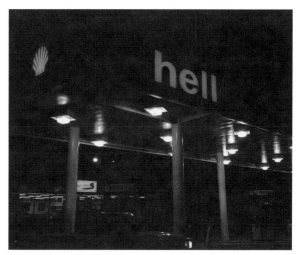

sHELL, Atlanta, Georgia, 1999.

EINE

If you don't remember your ABCs, Eine's work will remind you. The London artist has transformed the city into a giant sentence. Brightly coloured letters scream out of shop shutters across the capital. The city becomes a puzzle waiting to be solved in some unknown way. Eine began creating graffiti as a child and doesn't have many artistic pretensions. His passions are vandalism and paint. "I've always vandalized things. I never thought it was a particularly bad thing to do. To me it always seems like a slightly naughtier version of knock-down ginger," he explains, referring to the game where children knock on doors then run away. "It isn't causing that much damage. At the end of the day you're only changing the colour of something." He realized he was too old to outrun the police, but didn't want to stop creating work. "I decided to do something that was friendlier—moving from graffiti to street art. Everyone can see it, smile at it and understand it to a certain extent. It appeals to a much wider audience," he points out.

He began with stencilled stickers and wall pieces of his name. The alphabet formed organically. "There were some shutters down Kingsland Road that I wanted to paint on. Rather than squeezing 'Eine' into one shutter, I used four shops to spell out my name." It was an inspiration to push things in more open directions. Instead of using his name, he made the work more anonymous. The pieces are made with emulsion paint and brushes, using a spray can to quickly touch up the outlines. He uses a circus-style typeface because it fits with the shutters' horizontal lines and is very easy to paint. Some of the letters have been done with the permission of the shop owners, others without. "I can't imagine anyone phoning up the police and saying someone's painted a giant letter on my shop shutter," he points out. In addition to London, Eine has painted the alphabet in Newcastle, Stockholm and Paris. He is also experimenting with other mediums—placing painted plastic cups into fences to create 3D words. "I enjoy doing it. You can read whatever you want into it. It's about as shallow as that!"

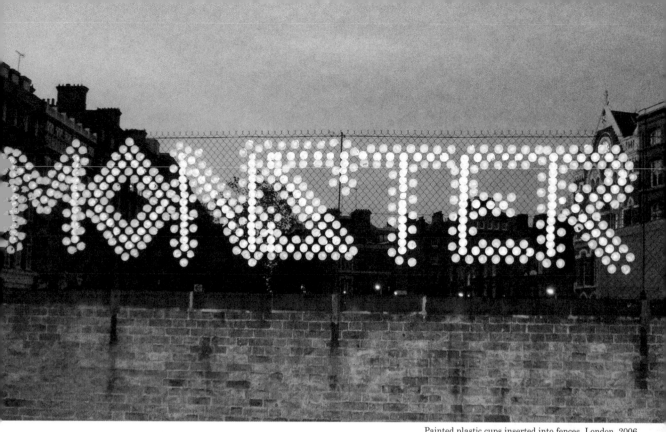

Painted plastic cups inserted into fences, London, 2006.

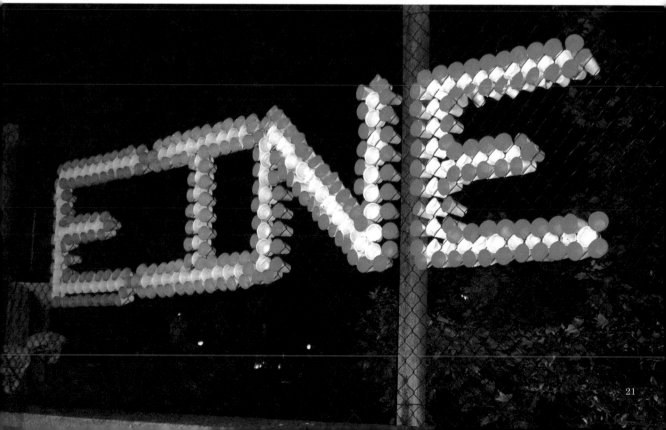

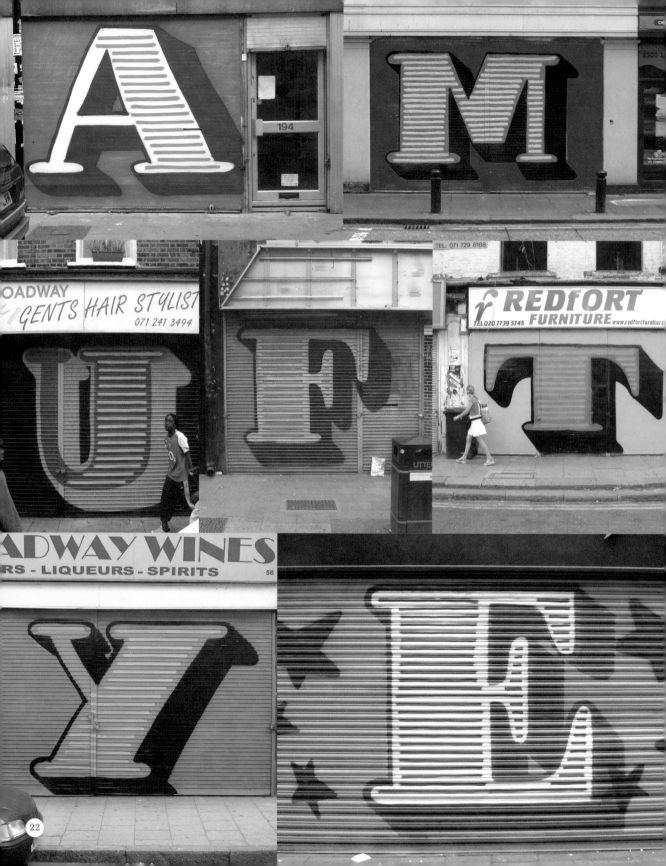

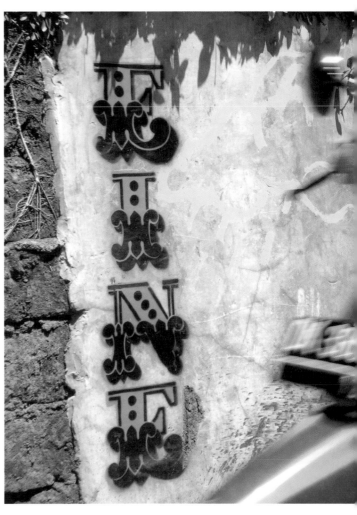

Opposite page: London, 2005.
Top: *Circus on Gloss Black*, 2005.
Above: Bali, 2004.
Left: London, 2006.

ELTONO

Eltono's abstract linear street interventions were a direct response to moving to Spain in 1999. "The technique I developed to paint in Madrid streets would not have been the same in another city. The backgrounds I find to paint in Madrid are not the same in other countries," he observes. His graphic pieces play with the squares, rectangles and linear shapes. As he notes "The day I find an all round city, I'll do round paintings. My forms just adapt themselves to the lines I find in the city."

There's a grit to the locations he seeks out. The urban space he explores, often in collaboration with his partner Nuria, is one in disintegration. "I really get no inspiration in a new and clean neighbourhood. I saw one time in Paris a graffiti that said 'Blank walls dumb people' and that's the way a brand new city makes me feel. I like old neighbourhoods with history you can read in its stones," he emphasizes. "The protagonist of the painted place is not my graffiti but the place itself that I try to enhance." His abstract paintings criticize the city's saturation with information and he consciously chooses the same colour palette as street visual communication—white, red, blue, yellow. "Everywhere you go you find a poster, an ad, a sign to inform you, to order you … The shapes Nuria and I create seem to be dumb. They do not exist to sell something or to indicate another. They just exist to offer the public an opportunity to think by themselves, react and freely interpret a mysterious symbol. We used to compare it to a kind of visual rest."

Recently he has begun to work on three-dimensional pieces he calls "Politonos", a reference to polygons. He creates sculptural objects that echo his linear forms. "I decided to do exactly like what I do when I am painting: choose a place, put an artwork on it and stop being the owner of the artwork. But a bigger piece can disturb the normal street life. So I made sculptures, put them on the street and hid to observe what happened around them. The first got destroyed, the second disappeared and the last one got stolen!"

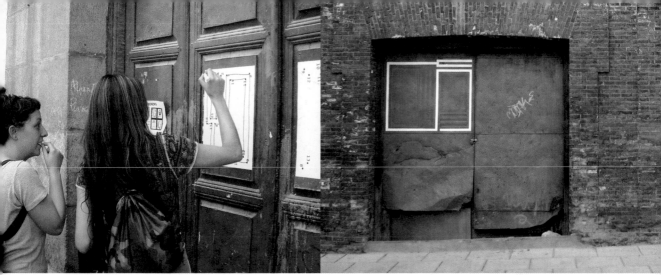

Above left: Madrid, 2001. Above right: Madrid, 2006. Below: Zaragoza, 2006.

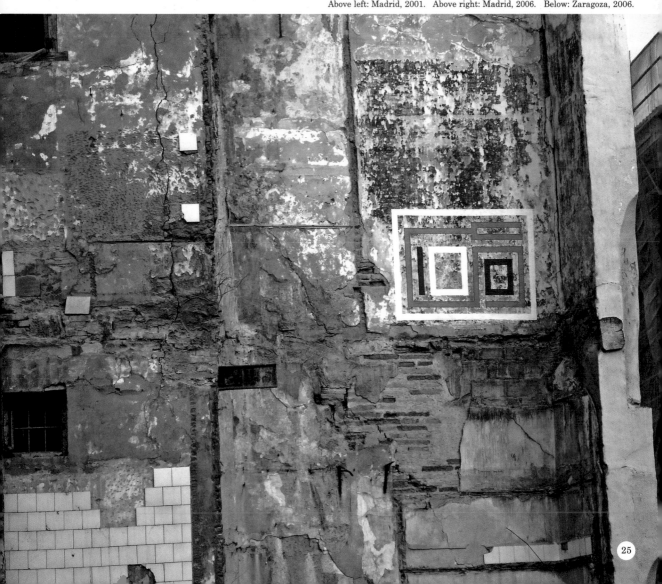

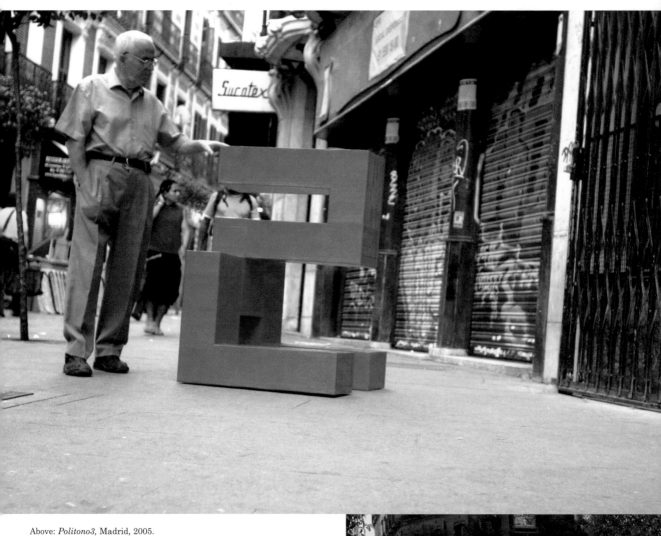

Above: *Politono3,* Madrid, 2005.
Right: *Politono2,* Madrid, 2005.
Opposite: *Politono1,* Madrid, 2004.

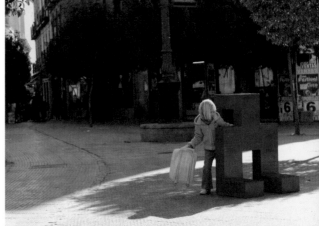

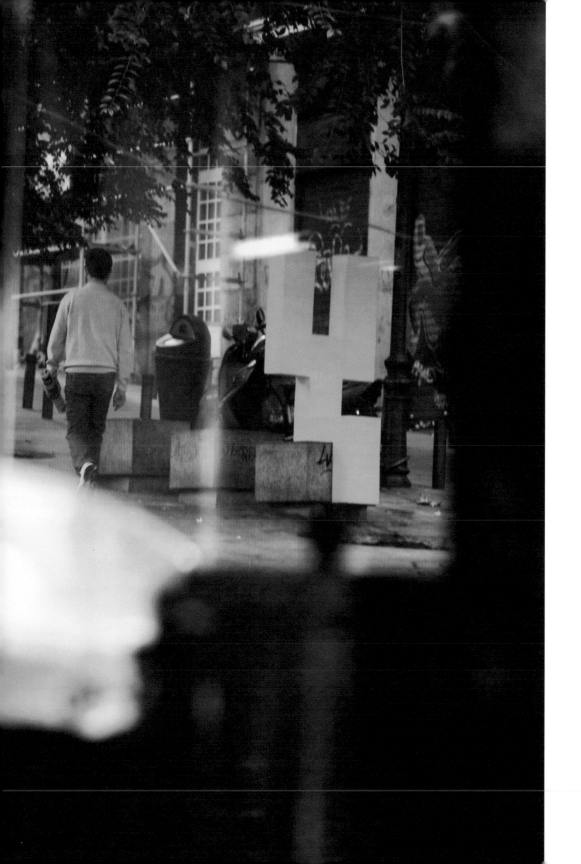

Perhaps failure is really a form of success. Faile formed in 1999. Patrick McNeil from Canada, Aiko Nakagawa from Tokyo and Patrick Miller from the USA came from graphic-design and fine-art backgrounds, rather than graffiti. They began creating wheat-pasted pieces when they joined forces, placing their ragged cut-and-paste posters alongside people like Shepard Fairey, WK Interact and Bast. "At that time, street art seemed to be really aggressive or propaganda-based. We really wanted to bring another side to that," Miller clarifies. They began with graphic posters of nude figures, but their poster and stencil work became increasingly jagged and began to echo the gritty spaces they worked on. The naturally destructive side of the city and its eroding environment was a cyclical influence on their work. "We were looking at the way the backgrounds or settings would change. How that surface or 'composition' would evolve over time," Miller notes. "As we started making more stencil pieces, we would hand-paint the background of the wall and enjoy the serendipitous approach it would create as the stencil went over this loose expressive paint."

Their work has increasingly been shown in galleries and they acknowledge the influence of artists like Rauschenberg, Cy Twombly, Jenny Holzer and Basquiat. Faile's work has easily crossed over from the street, though the illegal aspect to their outdoor pieces is important. "I think, from a political standpoint, it is about the freedom to go out and have a voice, despite the consequences," Miller stresses. That political edge has moved over into the content of their canvas works. They draw directly from newspaper headlines as in the "War Profiteers" series. "We gathered discarded paper scraps and trash from the streets around the studio in Brooklyn and from found newspapers in the area. They were then sifted through and collaged into compositions." Miller explains. The work looked at how media, governments and warlords all took advantage of the situation to create the war in Lebanon in 2006. "The aim was to look at the way the American, Israeli, Syrian and Iranian governments manipulated the situation for selfish motives and the ways Hezbollah and the Israelis spun the war to their socio-political advantage." Here rubbish and discarded urban ephemera changes to become a reflection of society itself.

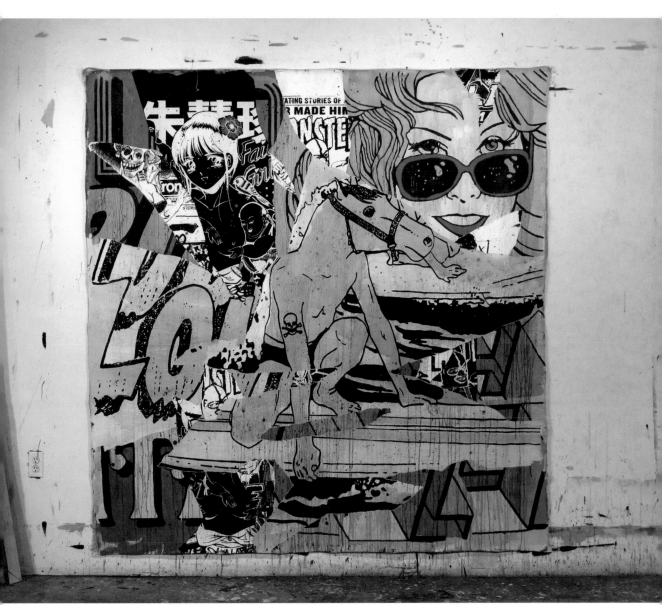

Shanghai Painting, Brooklyn studio, 2006.

Clockwise from top left:
Barcelona, 2006;
New York, 2006;
New York, 2006;
New York, 2006.

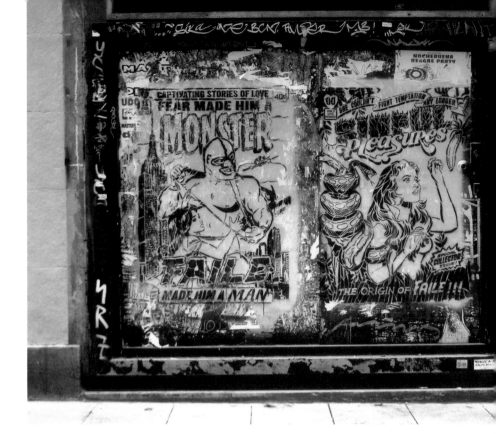

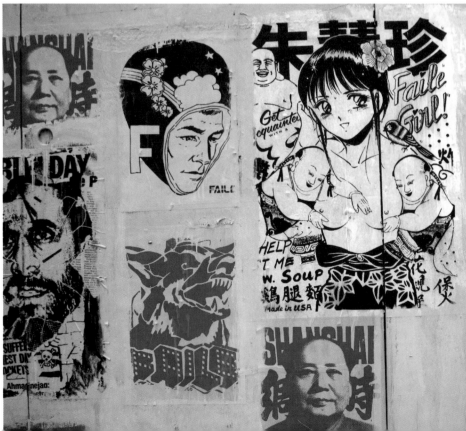

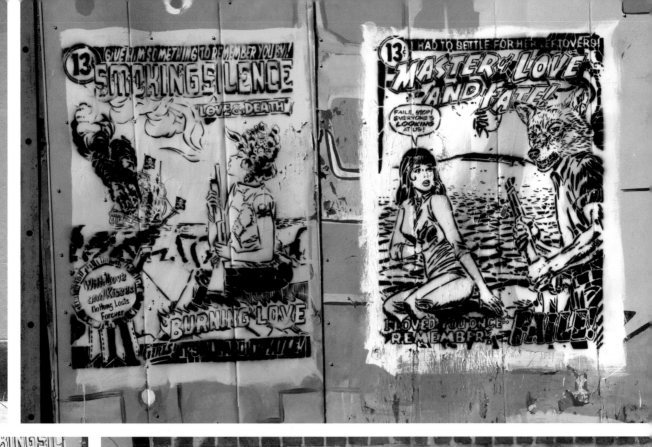

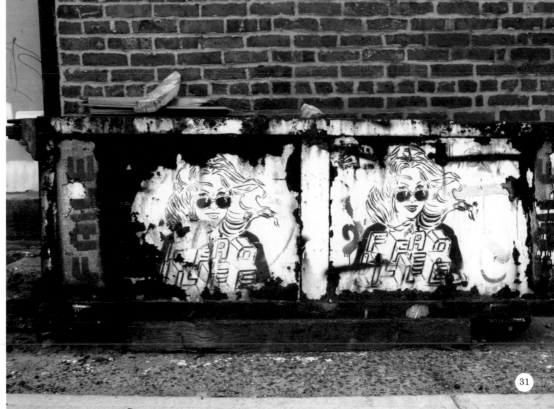

CAYETANO FERRER

In Cayetano Ferrer's work the invisible becomes three-dimensional. His "City of Chicago" street sign pieces look like they have become transparent and literally absorbed into the city around them. "The [signs] only enter your consciousness if you are parking a car," Ferrer observes. "I never drove in Chicago, so they were almost invisible to me. I wanted to freeze the moment that I actually looked at them." He photographed "No Parking" signs and pasted the images onto the signs themselves, creating a kind of perception game where the signs seemed to pale away and get stuck in time while the surroundings changed subtly. "I like the approach of manipulating these existing objects to change their meaning."

Ferrer's background was a large influence on his work. His parents created scrimshaw craft works and mosaics out of found objects to support the family. His older brother was a graffiti writer, while Cayetano was drawn to street skating. "A good portion of my work involves appropriation, which is the impulse that fuelled my curiosity back then; re-imagining the architecture and shifting its use. When I read about Situationism and Guy Debord's essays about 'derive' and 'detournement', I felt a strong kinship."

His "Empty and Lost" series appropriated the urban background as the medium. Ferrer photographed street signs, maps and advertisements on trains in downtown Chicago and used Photoshop to erase all their text. Billboard advertisements and directional signage were broken down to minimalist blocks of colour. He later distributed printed-up versions of these abstract signs across the city. His street work is more about manipulation than mutilation. "I try to tone it down by making it boring to make it seem less destructive. I call it 'blandalism', it just blends right in or confuses people," he explains. More recently, he reproduced 100 product packages without any text or content and hung them on a pegboard like a store display in an empty street lot. "I'm more interested in the specific place I'm putting it rather than this broader concept of the street. There can be different meanings attached to placing something on a building in the process of being demolished, or under a bridge or on a sign. History is important."

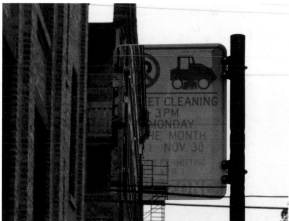
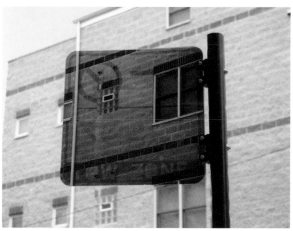

Street sign pieces from the
"City of Chicago" series.
Clockwise from top left:
Chicago, 2004;
Chicago, 2005;
Chicago, 2005;
Chicago, 2005.

Pieces from the
"Empty and Lost"
series.

Left:
Chicago, 2006;
Chicago, 2004;
Chicago, 2006.

Opposite:
Chicago, 2006.

SAMUEL FRANÇOIS

Although Samuel François's early background was in spraycan art, it is not an obvious element in his work. After studying fine art, interior design and architecture, François realized that he wanted to move beyond the restrictions of graffiti. "Graffiti is limited to writing a name. I felt frustrated and thought that the best way to develop new work was to leave it. But obviously it will always have an influence on me and on my practice, and the way I perceive things."

François's interventions often occur in empty rural or semi-industrialized places, reflecting the fact he grew up in the country. It is an interesting contrast to the urban-centric interventions of most outdoor work. François injects vibrant colour into the landscape—painting fence posts or alcoves in trees. He also works on old bunkers and factory buildings. The results question the place of decoration in society and its surroundings. "When you live in the countryside, you do not see the things the same way. You haven't got the same social image. The role of the suburbs in the French landscape and their problems challenged and interested me. But I don't live with these issues—I live very quietly." That doesn't stop him creating work in the urban environment. These pieces, however, are abstract and conceptual. He sometimes blows up balloons of the same colours, for example, and leaves them floating in adandoned places.

Many of his outdoor pieces were originally created as one third of the art collective Inkunstruction, formed in 2000 with friends St Brece and Pico, though he now focuses on his own projects. François currently lives in Berlin which is a huge influence on his current work. "It's very dynamic and driving for different projects. I work with photographs. I am interested in the space between destruction and rebuilding, constructions made by homeless people, illegal gardens." Much of François's work has moved indoors to gallery spaces but it still reflects the outside, such as his B-Bois characters made of trees and trainers. "The role of nature in the city interests me—its representation, its evocation. I play with that but it's also a way of speaking about oneself."

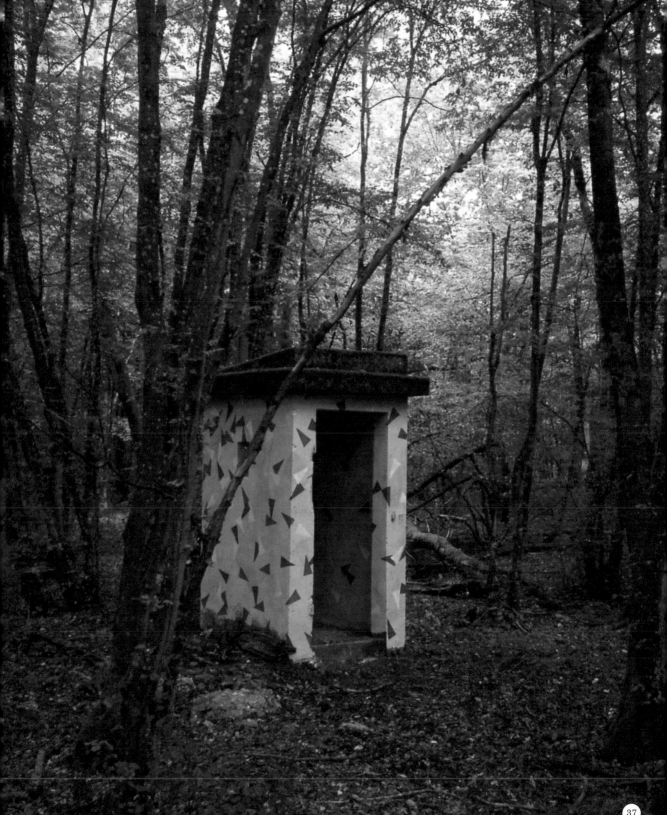

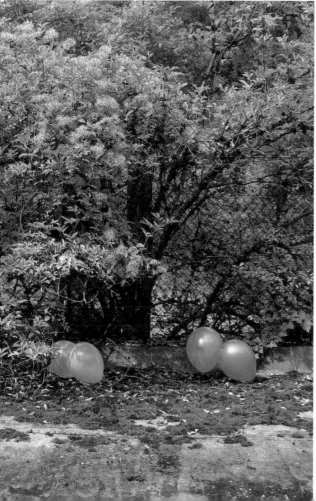

Page 37: *Pattern*, France, 2006.
Opposite page: *Confetti*, France, 2006.

Clockwise from top left:
Pattern, France, 2005;
Pattern, France, 2005;
Pattern, France, 2005;
Spontaneous (video), France, 2006.

City streets are brimming with photographic images but largely they are commodified placards of consumption and advertising. The photographic street installations of Parisian G* (real name Jerome Demuth), however, beat ads at their own game. He began pasting up his black-and-white photographic images around 2001 as "an egocentric and selfish way to show the public my photos". The scale of his giant images is at least life-sized and often larger. Often they dwarf people with their size and impact. "I'm just trying to 'paste' another reality ... I want to play in the public space. I create a sort of black-and-white mirror. An extra decoration," he explains.

His pieces fit like large puzzle pieces into the urban environment, echoing Paris's architectural lines. Exploring and responding to the imagery of the city is at the heart of G*'s work. "It's the source of all. Both the root and the goal of my work. Both the production tool and the final support. It's just an everything." His car images transform vehicle fronts into menacing and evil faces across the city. In Demuth's car series, technology was taking over walls as well as streets. Other political pieces look at issues around protection and repression, control and power, revolution and domination. Under the architectural banner of liberty, fraternity and equality G* blew up images of riot police with small highlights of blood red or acid yellow. The authorities were not very pleased with the controversial results in the wake of the Paris riots in 2006.

He declares his work is strongly inspired by the "Théorie de la Dérive" by Guy Debord and ideas of psycho-geography. Alongside the Situationists, Demuth reflects the influence of artists from Christo to Martin Parr. Yet alongside his "high art" inspirations, the illegality and destructive element of street work is essential. He mentions Hakim Bey's concept of a Temporary Autonomous Zone (TAZ), a temporary space outside the formal structures of control. There is something confrontational about his images. He's openly anticapitalist and political in his approach. He says, "A media able to fight globalization with the same weapons in order to have alternative and independent power ... this time it's not about DESTROY but CREATE."

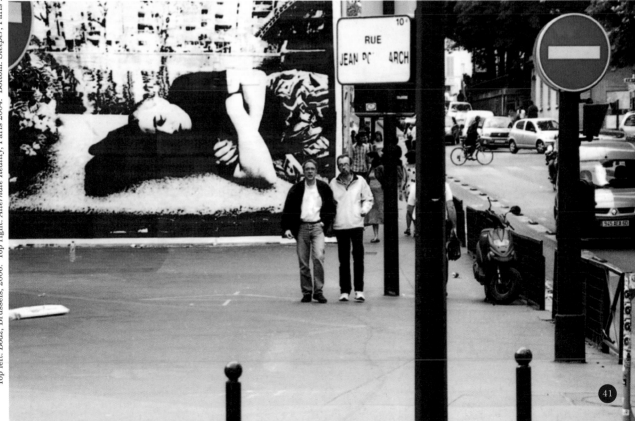

Top left: *Boaz*, Brussels, 2006. Top right: *Alternate Reality*, Paris 2004. Bottom: *Sleeper*, Paris 2004. Overleaf: Paris, 2006 ("Aux Arts Citoyens" collective show).

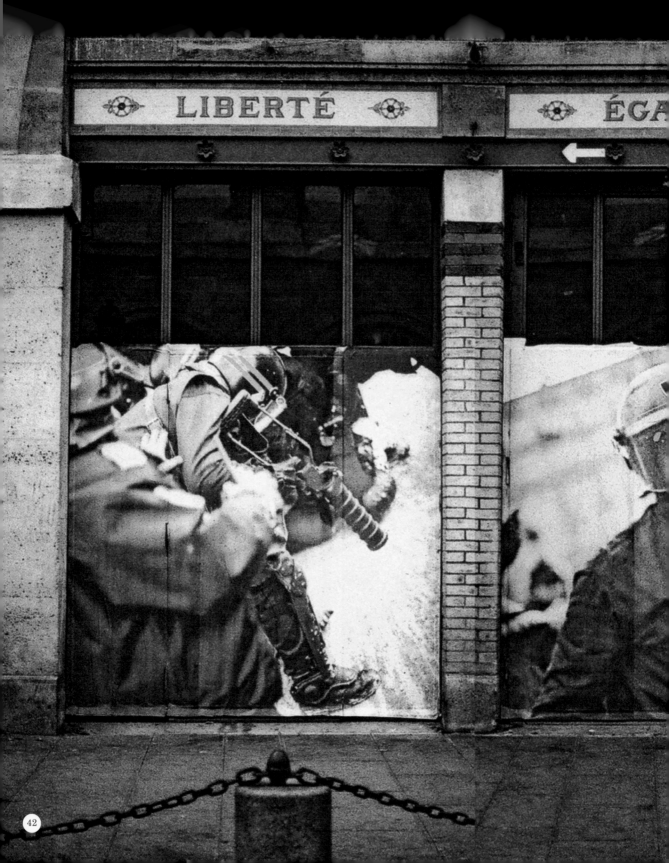

MICHAEL GENOVESE

Michael Genovese's text pieces seem to slide across boards and walls. His street installations and murals transform the edge of graffiti with a sense of elegance and poetry. At the same time they inject decorative text with social resonance and politics. Although he has a background in graffiti, he also began as a sign painter on a travelling carnival and later in the sign industry as a draughtsman artist. "I've always been into handwriting analysis, calligraphy and gang graffiti," he explains. "Hand-lettering is attractive to me because of its subtlety and its aim to communicate a message not only through words but through its ability to provoke an emotion based on line and form."

His first street-art pieces were made alongside Chris Silva to promote a gallery exhibition entitled "Hope and Love". "We would take pieces that were hung in the gallery after the show and install them on the streets in high-profile locations," he reflects. His aim was to connect to the public outside the art world. He later installed pieces in defunct shop and restaurant windows, on roadsides, and behind barbed-wire fences in abandoned lots. There is something tragic and poetic about much of his work. He plays with a city in decay. The work is often more about human emotions than just street locations. A small sign hidden by a motorway is painted with "Old Worn Out Memories" in old-fashioned type.

Some of Genovese's pieces are created using found objects alongside his painted text works. He transforms bits of wood, advertisements and street ephemera into a sculptural shed or boat in his collaborative "Tragic Beauty" series. Other works are as much about community as they are about aesthetics. "Lo que Puedes pagar [Pay what you can]" is an ongoing public art project where he hand-letters scrap-metal collectors and food-vending carts. "I document the process with audio recordings, photography and remnants of the experience to reflect on the interactions," he points out. It's a way of capturing a culture in decline as a result of increasingly restrictive laws that view vendors as an eyesore or menace to taxpayers. His hand-painted signage highlights their cultural importance before they vanish.

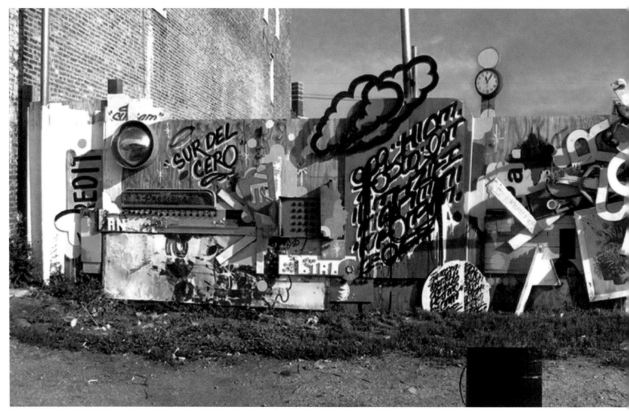

Chicago (with Juan Angel Chavez and Cody Hudson), 2004.

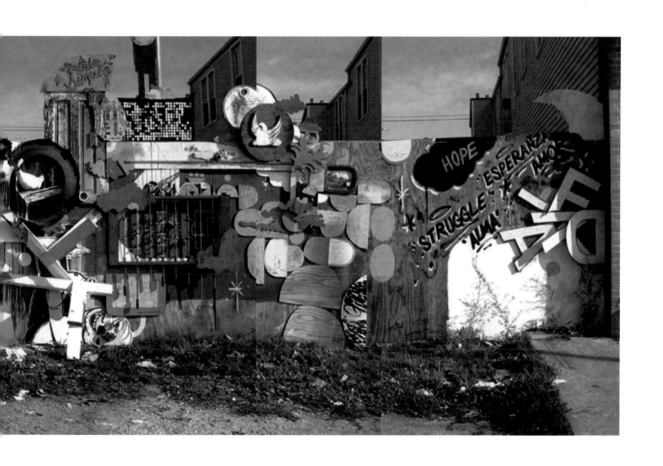

GRAFFITI RESEARCH LAB

Even nerds can be creative. Graffiti Research Lab is spearheading a new wave of "geek graffiti", where technology is increasingly part of street interventions. "Writers and street artists are naturally hackers and inventors," GRL points out. "They modify markers, make their own ink, experiment with new materials, defeat sophisticated security systems, devise clever ways to handle and dispense acid and other caustic substances. The GRL is just an extension of that tradition." Evan and James of GRL describe themselves as "two engineer/artist types with a lot of free time on their hands". The pair worked together at Eyebeam Openlab, the New York company that gives them some funding, resources and a space to work. They began making and putting up street pieces in January 2006. "Initially we did it to see if we could get someone to call the bomb squad. Now we do it to encourage people to use technology to take back control of their cities," they note.

Their most infamous pieces involved LED throwies, little LED lights that can be literally thrown and reconfigured to produce day-glo art pieces. "We were just fucking around," they recall. "We were trying to think of something really simple that would let writers compete with advertisers and get their work up at night. To make a throwie you just wrap tape around an LED, a battery and a magnet. They last one to three weeks depending on the power needed to light the LED."

The pair have collaborated and created tools for graffiti writers, artists and activists such as AVONE, BORF, Theo Watson and Lonely Guy. "Some of our projects come directly from artists, like BORF who asked us to work with him to put together a protest bike with a giant speaker on the back." One of the most interesting collaborations was with Mark Jenkins, for which they filled one of Jenkins's tape sculptures of a baby with glowing red LEDs. They are currently working on DIY laser projectors, balloon bombing, paint bombs and taxidermy. Many of their pieces seem to be openly political—commenting on consumerism, against the Bush government and around ideas of what is public and private. As they highlight, "I think just having uncurated fun in a privately stolen city like New York is a political statement."

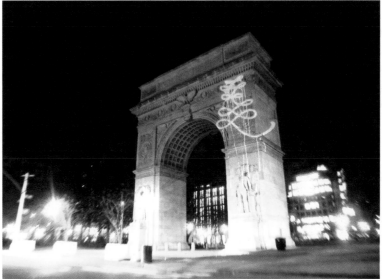

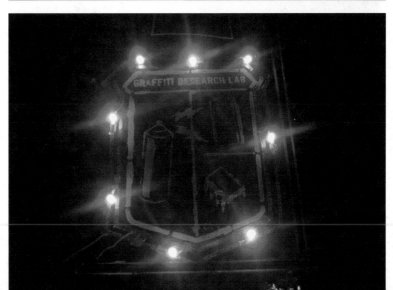

San Francisco, 2006;
New York, 2006;
San Francisco, 2006.

Page 50:
New York, 2006;
New York, 2006.

Page 51:
Collaboration with HELL
and AVONE, New York, 2006.

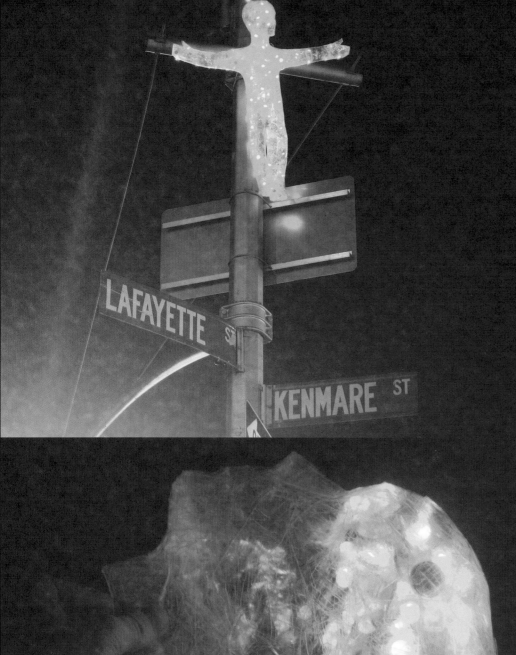

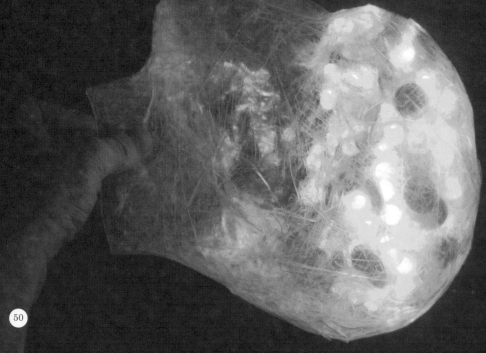

INFLUENZA

It's impossible to pin down Influenza's work. The only thing that really holds it together is humour—and its street setting. His pieces range from manipulated urinals and urban games to fingerprint stickers. His "pointless oneliner" is a black spray-painted line that moves along the street, across walls and windows. He creates other spray pieces that merely mark and measure the length of a wall. "The Art of Urban Warfare" project invited people to collect military imagery and make them into stencils in one of three game colours—green, blue or brown. The project went international and created an alternative visual world gripped by war games. Many of Influenza's pieces are openly funny. "Laughter can open up the dialogue sometimes. At least it helps some people to get over the first limitation—that the work is only vandalism. It is a great sales technique," he explains.

His "information blackout" series was a response to the aggressive club fly-posting culture. He began to paint over all the text on posters, transforming them into abstract designs. "At first the aim was to simply reduce their appearance in the streets and later to convert their visual influence into something more element-ary." However, the project had an unusual side effect. "It's interesting once you are in the middle of realizing a project like that and you start to see the influence of one language shift towards the other over a period of time. You somehow realize you're converting the look of the city into a gigantic drawing."

The large scale of his projects relates to the fact that Influenza sees his work as a direct reaction to the public art tradition in the Netherlands. Somehow his work is a reaction to the ugly, modernist public sculptures that have dominated the country since the 1970s. His pieces question why one art form is accepted and another rejected. He is also fascinated by the way his work develops and lives on after its installation. "The weather, law enforcers, public opinion, the army of graffiti warriors … A well placed intervention shows the power and the dynamics of the street, its culture, its history and its limitations."

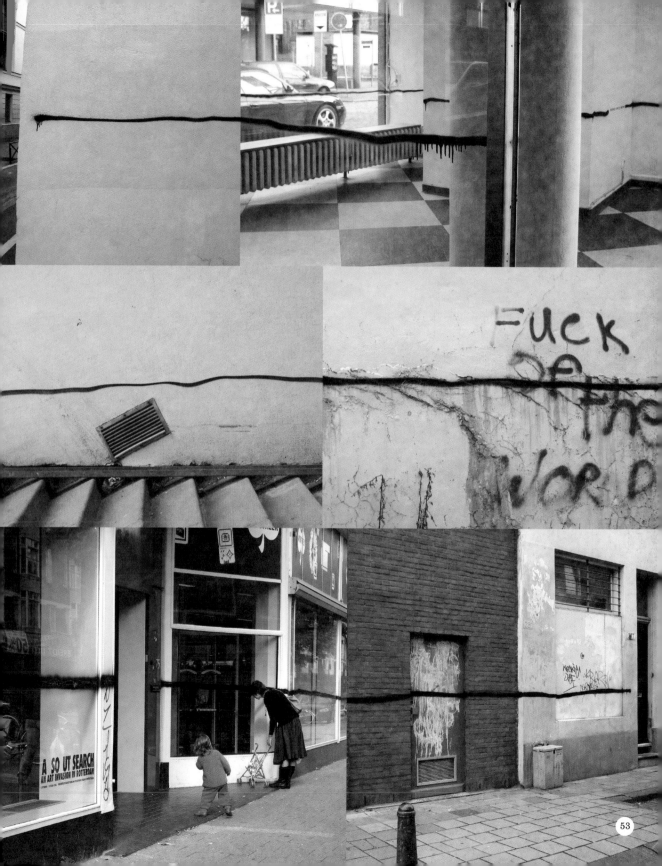

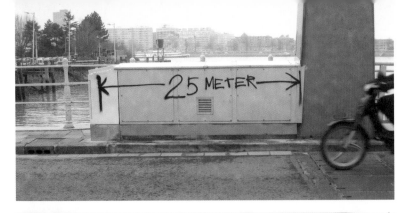

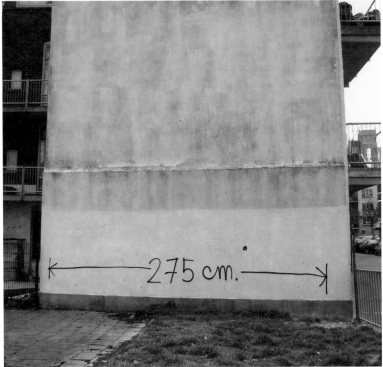

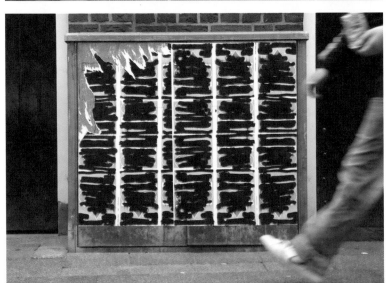

Page 53:
Pointless Oneliner, Rotterdam, 2006.

Left:
Exaggeration, Rotterdam, 2005;
Exaggeration, Rotterdam, 2005;
Information Blackout,
Dordrecht, 2006.

Opposite:
15,000 Most Popular Words in Advertising (in Random Order),
Romania, 2005;
The Art of Urban Warfare,
Prague, 2004;
The Art of Urban Warfare,
installation view, deFabriek,
Eindhoven, 2003.

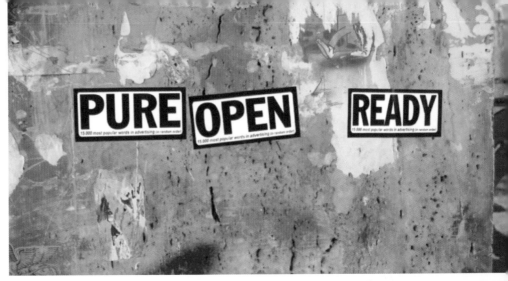

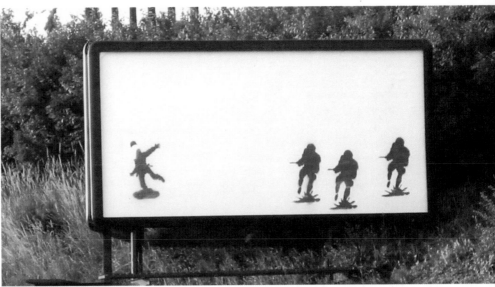

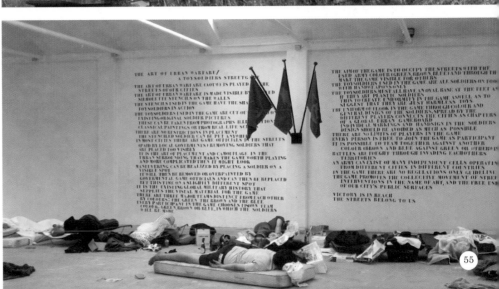

INVADER

Invader did numerous art projects before he hit on the Atari computer game character. But the pixelated alien stuck. His retro characters made with mosaic tiles have been cemented around the world. The graphic injections always fit, whether they are on Avignon's medieval walls or amongst Tokyo's techno chaos. Invader's attraction to the basic 1980s imagery was partly due to the appeal of the low technology and how early videogames pushed conceptual boundaries. At the same time was the realization that "space invader" could mean "invasion of space".

His invasion has longevity. There's a sense of permanence to his pieces that many street artforms don't work with. Where many pieces are ephemeral, Invader's colourful squares refuse to budge. He's aware of the tension between permanence and the transitory in his work. "The material I use (tiles and cement) are made to be permanent, but at the same time I know that nothing is eternal especially things you do in the streets!"

He has moved beyond mosaics to pieces made from the ultimate 1980s fad—the Rubik's Cube. "It was a logical evolution of my work. One day I went on eBay and bought a few dozen to see what I could do with them. I think it was also a way to go from the square to the cube, from 2D to 3D." He has also created giant three-dimensional sculptures of his Rubik's pieces. This large-scale experimentation was continued at a gallery show at Newcastle's Baltic Mill, where he created a giant stained-glass window of the Atari character. "There was this huge window at the top of the building and I thought it was a great spot to make a piece, because it is both inside and outside. During the day you have to be inside to see it because the light is outside, and during the night when they put the lights on, the window resembles a huge screen." The project is constantly being reinvented. Invader sells DIY invader projects as art editions for fans to collect and put on or in their homes. He has even created trainers with space invaders imprinted on each sole. "Each step you walk leaves the mark of a space invader," he enthuses. Here life transforms into a big game.

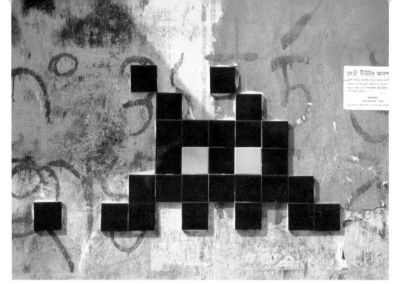

Page 57:
New York, 2003.

Left:
Paris, 2003;
Paris, 2006;
Dakha, Bangladesh, 2004.

Right:
Los Angeles, 2006;
New York, 2003.

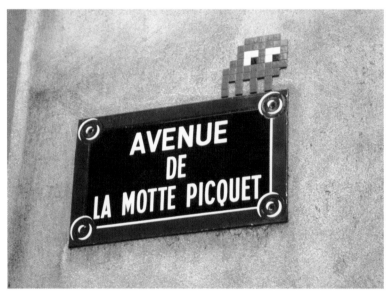

AVENUE
DE
LA MOTTE PICQUET

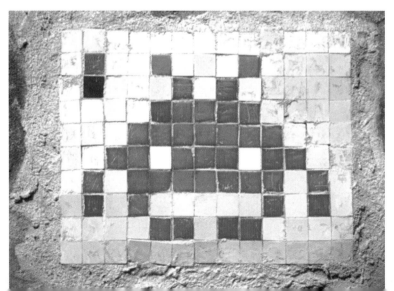

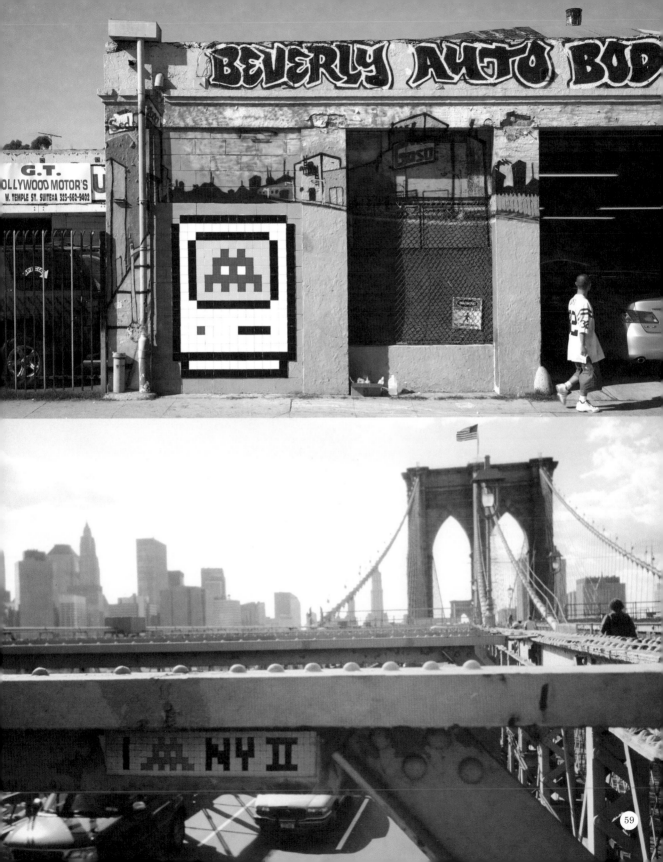

MARK JENKINS

When it comes to inventive use of materials, few can surpass Mark Jenkins. The Washington D.C.–based artist first started experimenting with adhesive tape in 2003, while living in Rio de Janeiro. He decided to make a ball out of clear tape using a technique he played with as a child. Jenkins covered objects with tape, sliced into the coating and removed the object leaving a cast. "Gradually my obsessive tendencies kicked in and I ended up casting everything in my flat including myself," he recalls. He started seriously putting things on the street on his return to Washington. In his "Storker Project", Jenkins cast a baby doll and left children hanging on trees or above shop signs, hinting at a strange opaque narrative. The juxtaposition of nature and urban space is a repeated theme in his work. Tape giraffes eat trees on the street or tape ducks float on puddles, while tape fire hydrants and parking meters turn up in green spaces. "We've obscured nature with our paved roads and concrete sidewalks so that the other species are pushed out," he notes. At the same time

he is aware of the strange natural element in the synthetic materials he uses. "The clear tape casts react like ice by allowing the natural colours of the forest and sky to pass through or reflect off it. It is a perverted equilibrium, but I also see it as healing the divide between the natural and man-made."

In his "Embed" series he dresses cast figures in old clothes to create hyper-realistic people that seem to dissolve into walls. The street becomes a space for interaction. "People approach poking, kicking and sometimes making modifications. I see them as part of the performance. I like leaving the works out there open-ended—as a sort of question mark against itself and everything around it." Jenkins often refers to his memorial-filled city as "the cemetery" and his husk-like pieces add a ghostly element to the urban "gravestones". "The shell (or husk) suggests the original object but as a sort of intangible essence that is a bit like a phantom presence … It allows the sculpture to act as a window into this emptiness that is the past."

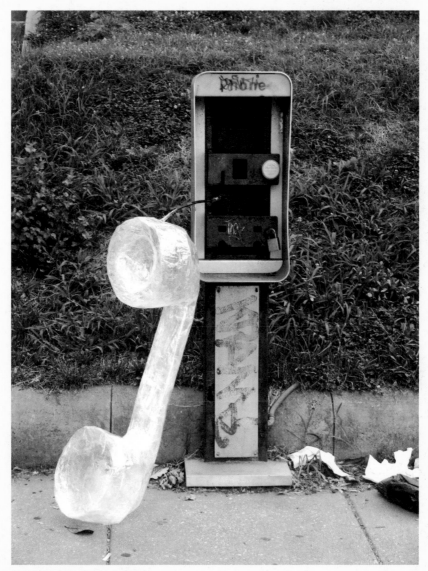

Call Waiting, Washington D. C., 2005.

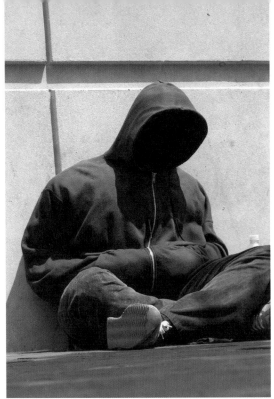

Left:
From the "Embed" series, Washington D. C., 2006.
Below:
From the "Embed" series, Washington D. C., 2006.

Opposite (clockwise from top left):
From the "Storker Project", Washington D. C., 2005;
Decoys, Washington D. C., 2006;
Street Extracts, Fairfax, Virginia, 2005.

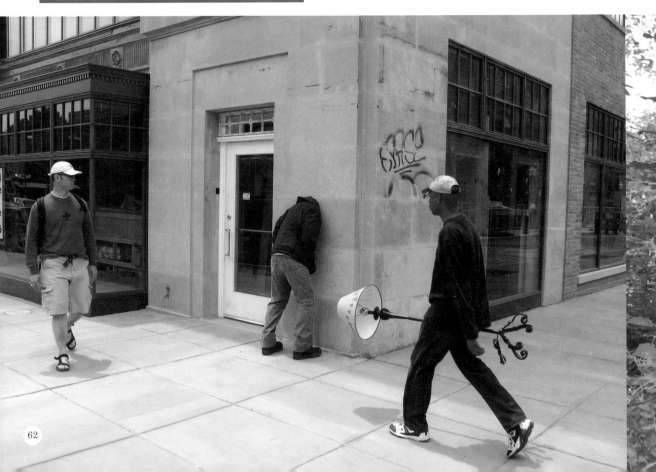

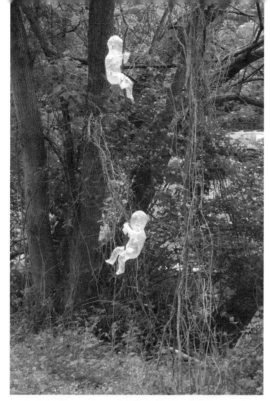
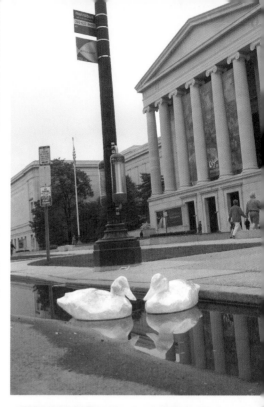
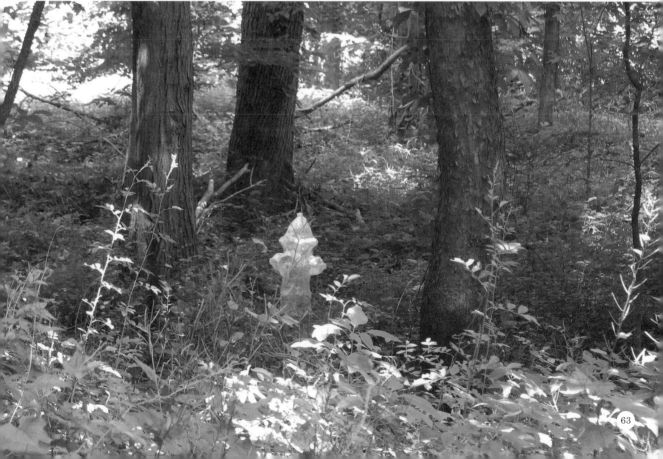

LEOPOLD KESSLER

Leopold Kessler takes the themes and arguments of the fine-art world and places them on the street. The results are a million miles away from graffiti. Kessler studied art for two years in Munich and six more in Vienna. He began creating things in urban spaces in 2000. "It was not a principle decision. I had an idea for a work outside and then others followed," he explains. Part of what makes Kessler's street interventions so engaging and funny is they often involve cleaning and fixing things that don't work. His first piece in northern Italy involved reactivating the chimney of an abandoned textile factory. "I've also started to repair neglected public items. I'm cutting a bush which grows over a street sign each year, so you can read the information." He has gone into train stations and fixed a broken display sign, installing "repaired by L. Kessler" beside it. The work becomes anti-vandalism and Kessler a kind of art handyman.

He amends the architectural minutiae of daily life in other ways. For "Privatized" Kessler installed receivers in streetlamps, so they could be switched on and off by a remote control. In his work the boundaries between public and private space blur. He put a lock on the door of a London public phone box so people making calls could have privacy. He erected birdhouses across New York City, which opened to reveal alcohol—playing with the city's anti-street drinking laws. In one shockingly brave piece, *Depot*, Kessler transformed the "O" of a sign outside a police station into his own personal storage space.

Not all of his street pieces are friendly. His "Trash Bins" series involved raising street bins until they were far above the height for functional use. Most of his works are created illegally. "I started to work without permission because I thought I would never get any. Then I discovered that this was interesting in itself. It means I'm acting as a normal person, without the privilege of being an artist," he observes. The work is often highly conceptual, but it still has a sense of simplicity to it. Kessler plays with the boundaries between the city and its inhabitants, the state and the individual.

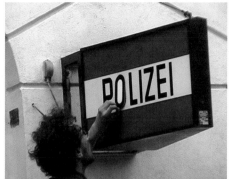
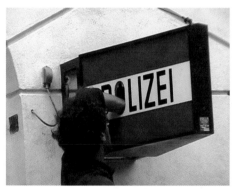
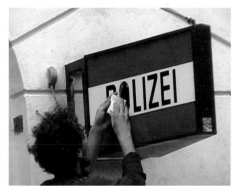
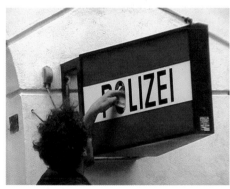
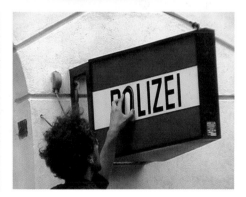

Depot, Vienna, 2005.

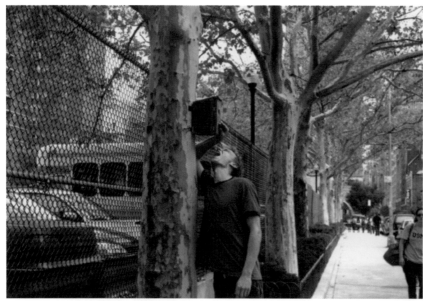

Birdhouses, intervention/video, New York, 2005.

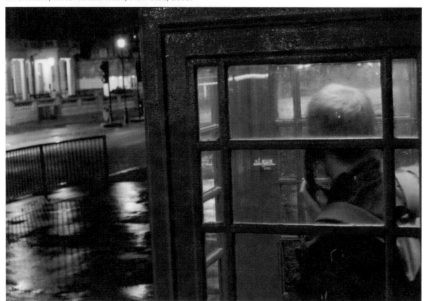

Secured, London, 2005.

Opposite:
Trashbin, Vienna, 2004;
Uncovered, intervention/
video, New York, 2002.

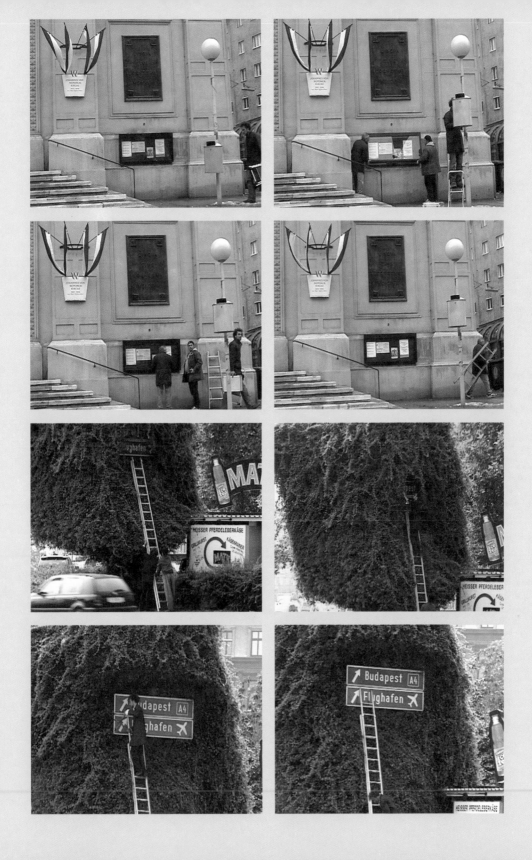

KNITTA

Street-art collective Knitta started in a rather haphazard way in October 2005. Shop owner Magda Sayeg "asked a friend to knit the handle on my shop's door. I wanted some colour. I don't think we were prepared for the amount of attention it got. I constantly saw people's reactions to it—touching it, asking questions about it. We put a piece on a stop-sign pole near the corner of my shop. It had the same reaction but even bigger." While working with four different knitting patterns, they set up a MySpace address and got immediate responses. After a few months, it was being picked up by the international press. Their work had been spotted after they had tagged New York—from Times Square to the "Welcome to Manhattan" sign.

The work is largely made from cheap acrylic yarns. Some of the creators were drawn to vibrant colours, others to fuzzy, textured yarn. "At first we crocheted the tags on, then we just tied knots. Now we're using zip ties, and it stays on longer," Magda explains. There's definitely a playful approach to the whole thing. The 11-piece collective (all female apart from one man) have names like PolyCotN (Magda Sayeg), Akrylik, Wool Fool, Loop Dogg and P-Knitty. Despite the comedy, there's an honest desire to beautify and interact with industrialized city spaces.

"We are attracted to the same concrete and steel environments as graffiti writers," Magda points out. They have tagged fire hydrants with knitted ski-hats complete with pompoms. They have made odd little cosies for ketchup bottles and antenna pieces for cars. In Seattle the group brought in volunteers for a commission to cover a column in knitting. The work was as long as the length of a house and took around 40 people to create.

It's understandable that this traditionally "feminine" medium would imply there is a feminist subtext to their work. However, this isn't something the creators ram home or even agree with. "The project questions the assumptions of knitting and it questions the assumptions of graffiti. Which is one of the reasons people quietly respond to it," Magda explains. "The aim is to beautify architecture. To expose people to something different. Sometimes beauty can be outlawed."

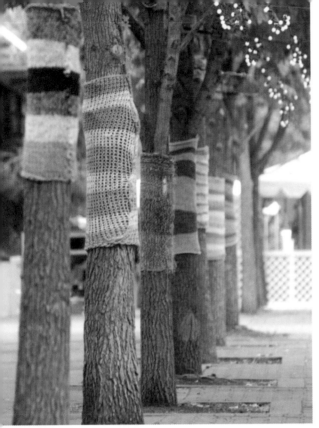

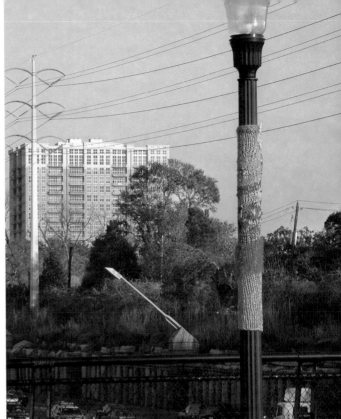

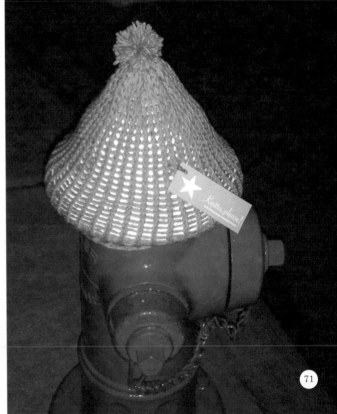

ADAM NEATE

Adam Neate started leaving paintings on the streets of East London in 1997. He realized his house was full of paintings and he had no space. "It was at that point I thought it would be quite surreal and fun to leave the paintings hanging in the street. Which I have been continuing to do to this day." Neate works on whatever flat surface he can find—canvas, wood, fridge doors, pieces of cardboard tacked together. He paints artworks in large batches from 20 to 100 and sets them free on the streets. One series, "The Refuse Collection", involved Neate leaving over 100 paintings among rubbish piles for binmen. For another series, "Left and Found", he hung canvases on every odd nail on outside walls he could find. "I like the idea that people should not have to only be restricted to seeing art in specific places like a gallery. Art can be everywhere," Neate points out.

It's impossible to pigeonhole Neate's style, something he consciously avoids in his search for creative freedom. "My main passion within art is experimentation, not to rely on a particular style or technique. I try and be as different as possible. For me, art is all about being creative, which means exploring new things," he notes. Painted canvases, abstract patterns, scrawled monochrome drawings, screaming bright characters all feature in his work. He's currently working on three-dimensional cardboard street sculptures. His influences include his wife, street artist Waleska, rainbows, waking up at 3am, pigeons, wet cement, spaghetti, flash floods and the kindness of strangers. What holds his work together is Neate's approach. His paintings briefly add to the world's urban detritus before they vanish, rather than amend or play with the architecture of the streets themselves. He litters the world around him with ephemeral gifts. "I like the idea that if I do a bad painting, it only remains on the street for a small amount of time. If I were to do a bad stencil on a wall, I would have to walk past it every day feeling embarrassed. I like the fact that nothing is permanent." The walls of his own home are bare. Here today, gone tomorrow.

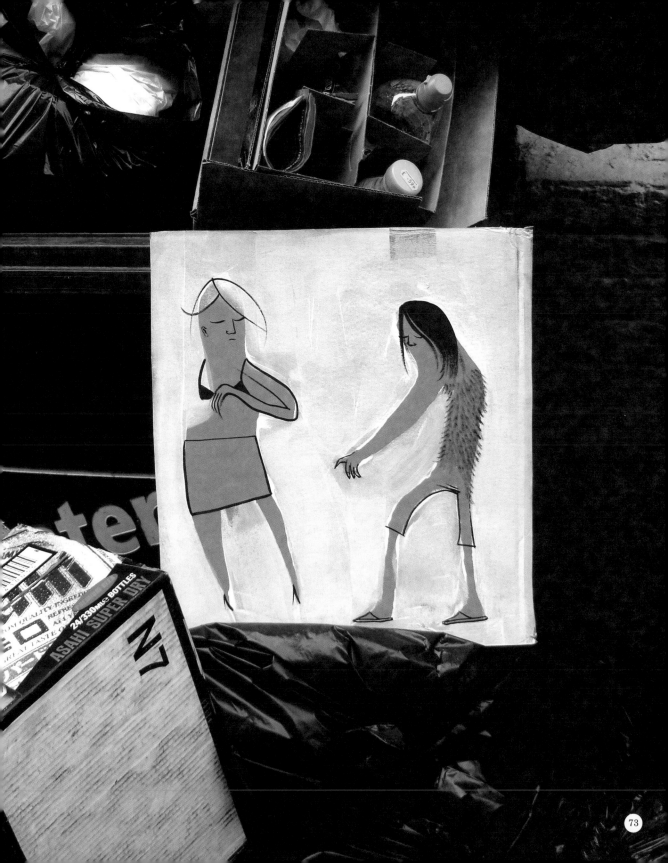

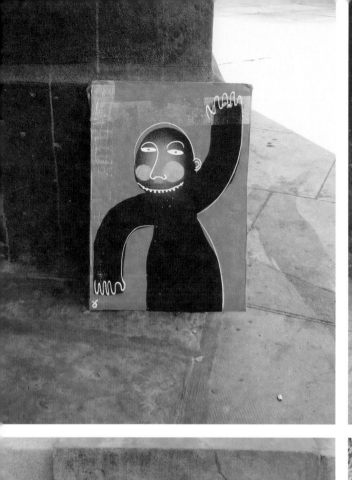

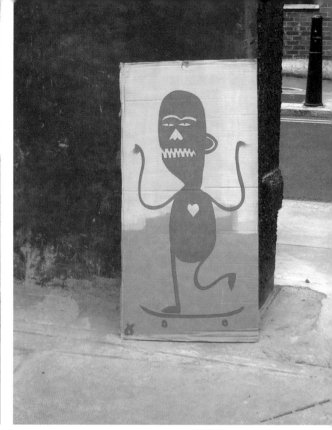

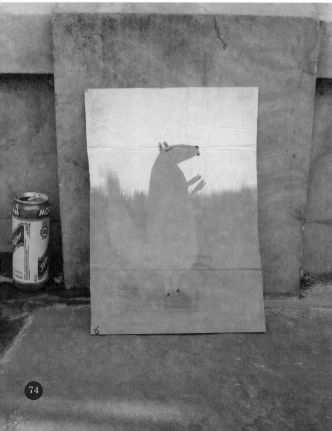

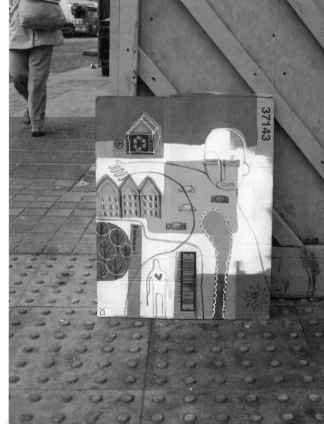

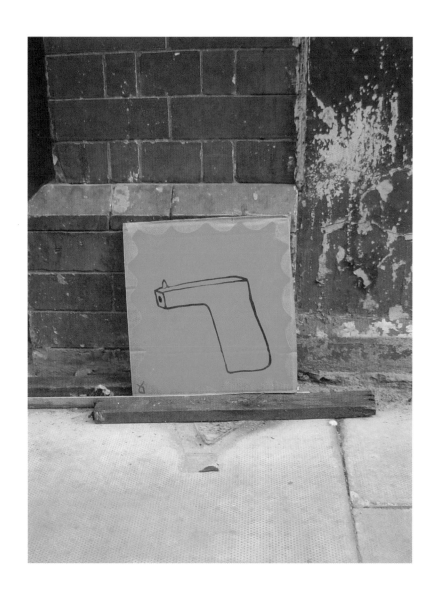

Page 73: London, 2006.
Opposite: London, 2006.
Above: London, 2006.

ON_LY

Simplicity is the easiest form of communication. Artist Carla Ly's sticker work is exceptionally simple. She creates plastic vinyl stickers that resemble coloured band-aids and sticks them around the urban landscape. Different-sized plasters are placed over disintegrating gaps in urban walls, over bashed rusty corners of car bumpers—over the battered, damaged remnants of urban violence. The results oscillate between humour and politics.

"It was a contagious idea that I caught, and I still can't get rid of," she explains. "It started in Caracas. It was easy to recognize, anonymous. It could be understood without any explanations." The stickers aren't just about the artist. How we interpret the pieces says more about our own perceptions of urban space, personal experience and the political environment. As she observes, "Its value is in how it penetrates our mind and memory. The format of the band-aid turns into a mirror." Ly is definitely aware of the wider emotional resonance of soothing urban cuts and bruises. She places the stickers "where I find the possibility to catch the glance of a collective memory. I touch the wound." The city becomes a manifestation of the human body covered in scrapes and scratches. As she describes it, "The resemblance of the body and the city are analogous to the memory of a scar." Her tags become less about her own identity and more about her relationship with her surroundings.

Ly was born in São Paolo, brought up in Caracas in Venezuela and is currently based in Valencia in Spain. She emphasizes the importance of free speech and protest in her work, pointing out that her main influence is "the indifference to differences". The sticker pieces are only one string to her varied bow. She also creates graphic pieces of a Medusa-like girl, surrounded by her hair, on found objects on the street and in piles of rubbish. Here she applies paint with cut-up rollers. "With each tool I touch and try, I see the possibilities that it gives me. This is where the technique and style comes from. Searching for a way to express myself." Ly's underlying aim is to transform public space into something subtly humorous, to convince the public to see the world less literally.

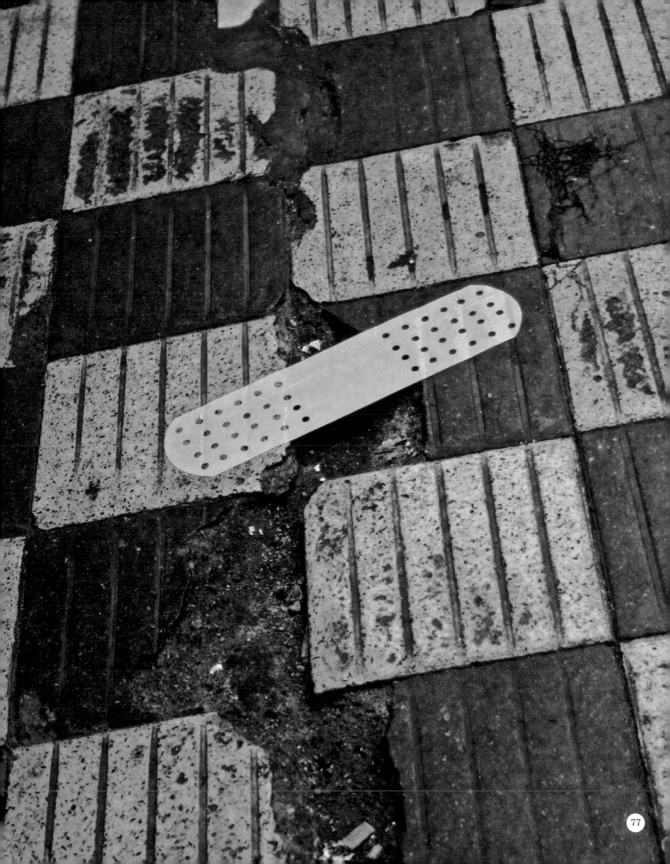

Page 77: Caracas, 2005.

Opposite (clockwise from top left):
Valencia, 2005;
Valencia, 2005;
Caracas, 2005;
Caracas, 2005;
Valencia, 2005.

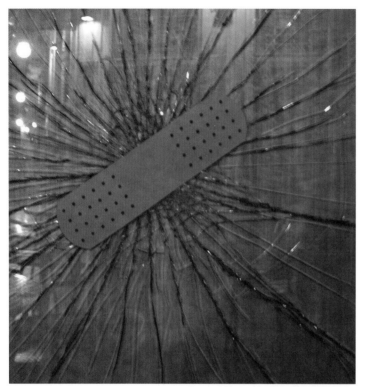

Caracas, 2005.

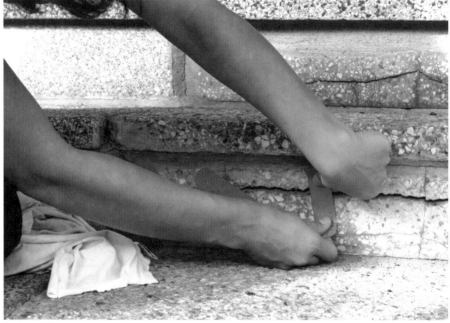

Berlin, 2005.

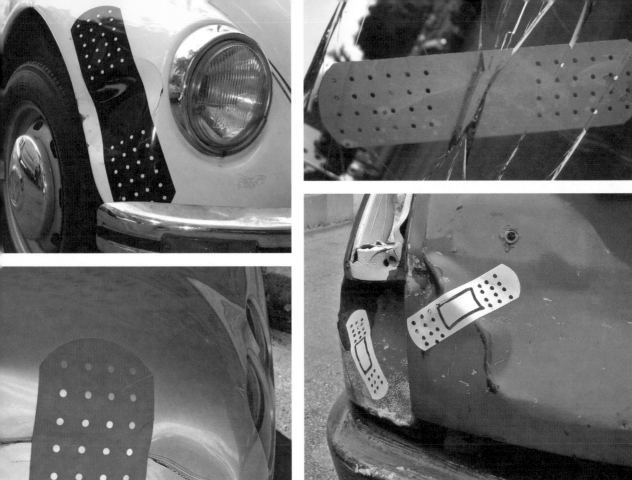
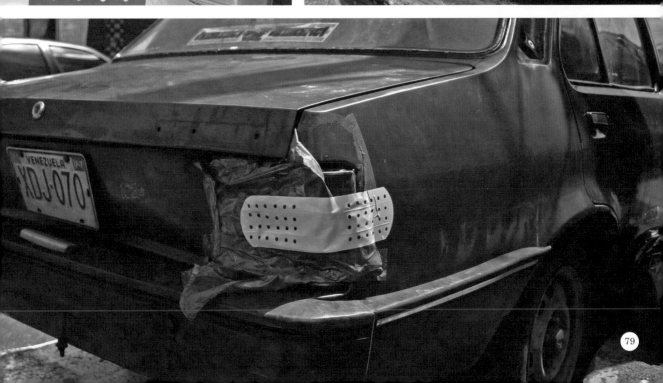

PART2ISM

At first Part2's street installations look three-dimensional. The pieces are in fact painted onto cardboard to resemble shifting, cubic texts. He was influenced by graffiti wildstyle—extreme takes on text and lettering. "I wanted to see how things can interact in other areas," he explains. "I thought I'd leave the spray paint out and base things around the font." The ex-graffiti artist, musician and member of the band New Flesh For Old, had a solo LP and CD out called *Live from the Breadline*. He decided to experiment with the square font on its cover.

In order to push his work further he created some personal rules. "No circles. No spray paint. No traditional graffiti effects." He places his cut-up boards against railings, bikes and stairwells. He is drawn to the metal grids and lines that criss-cross the city—places that echo the "techno" edge of the pieces' construction and design. He consciously works against graffiti's established approach. "I look at everything around me as a reverse role model. I work on fences because you traditionally paint a wall. I like the fact you get traffic going past behind them and it almost makes the work feel transparent," he points out. The same applies to the locations where he puts his pieces. His current work reaches an audience far wider than the confines of the graffiti scene—few people glimpse painted trains before they are cleaned up.

His work is intentionally low-tech. It's created with scissors, glue, cardboard and photocopies. There's an abstract element to the cut-up texts—an approach echoed in his music. The aim is to inject fluidity and speed into still objects and the rigidity of lettering. "I'll work on a square and then I'll lean it. You get this kind of movement in the letters—slicing and interlocking. It's a cut and paste, 'William Burroughs on the street' approach. I like shifting things." Future plans include creating three-dimensional pop-up objects that use the mechanism of an opening door. "I'd love to use public phone boxes. When you'd open the door, characters would pop up. I've tried lifts. I like to use the environment as a playground."

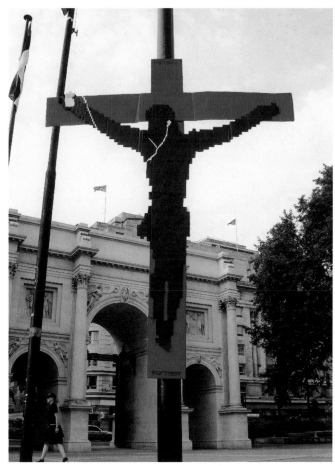

i-God, London, 2006.

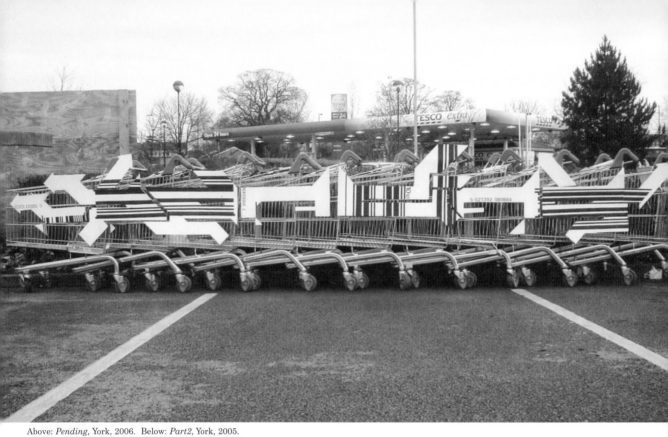

Above: *Pending*, York, 2006. Below: *Part2*, York, 2005.

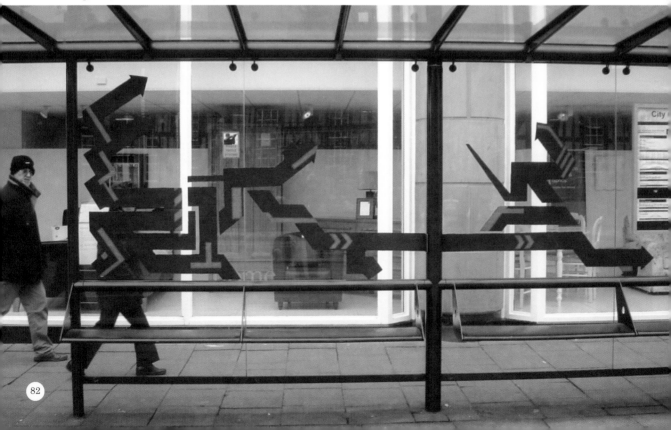

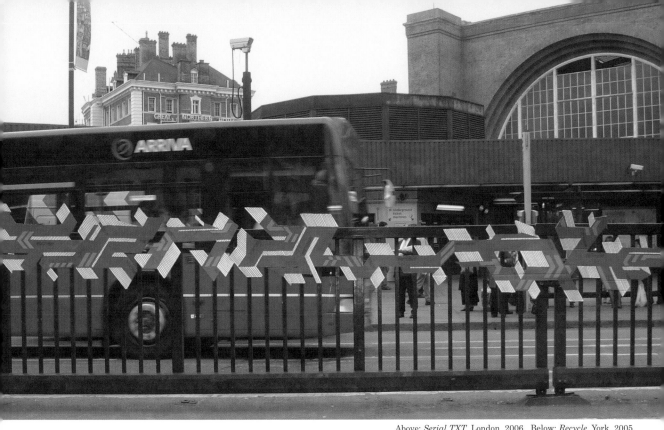

Above: *Serial TXT*, London, 2006. Below: *Recycle*, York, 2005.

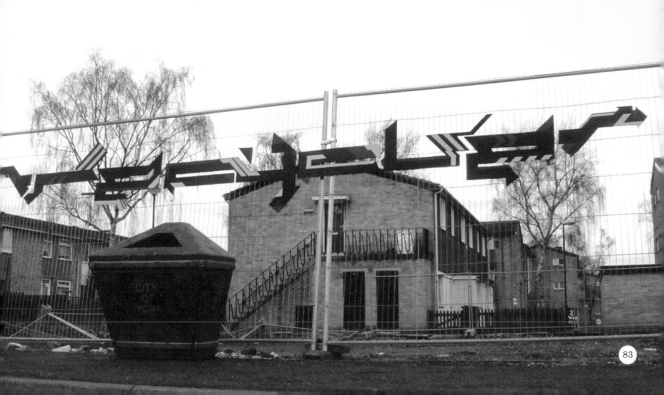

PSALM

Australian artist Psalm transforms garbage into gold. Psalm studied architectural drafting and graphic design, but first started creating quasi-religious stencil pieces in 1999 after doing graffiti for a decade. "I'd become bored with graffiti, and didn't feel as though I was advancing any further. So I started to look for other ways of expressing myself. I'd also become disillusioned with the whole politics of graff. Stencilling was a breath of fresh air for me and has led to a host of other ways to express myself."

His debris pieces are his most innovative street works. He installs strange sculptures made of found objects on brick walls. "One day I was having a clean out and I had some old toys laying around and instead of just throwing them out I thought I'd create something with them and place it on the street." The pieces often playfully come with gallery-like title credits. Sometimes they partially involve paint or stencils. Other pieces are made solely with found things. The streetscape itself isn't a major influence on the work's content. Psalm sees it simply as a platform to display the work. The illegal aspect of the work is also not his main focus. Sometimes he sources materials for specific ideas, at other times he's inspired by an object he stumbles across on the street. Nearly all the pieces are placed on standard brickwork. "I can attach a small L-shape hook to the back which rests on the mortar gap between the bricks. It gives the liquid nail glue a chance to bond. If I just relied on the glue to hold it up, it would slide off the wall," he explains.

The sculptures openly push the boundaries of what is acceptable on the street. "I liked the idea of guerrilla sculpture. I remember seeing in my local paper that someone had secretly installed this steel sculpture in the local park. It was only small but the council took it away because of safety and planning issues. I just thought what a load of shit bureaucracy is. Wouldn't it be nice to create something unexpected without having to justify it?"

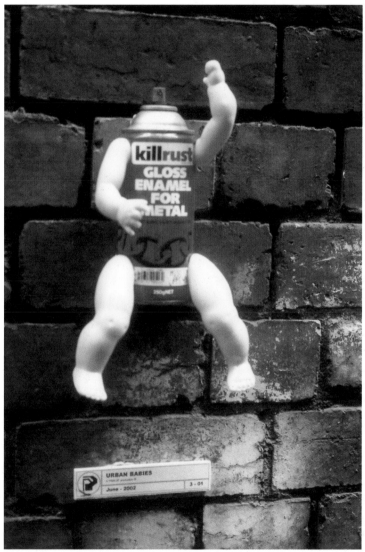

Urban Babies, Melbourne, 2002.

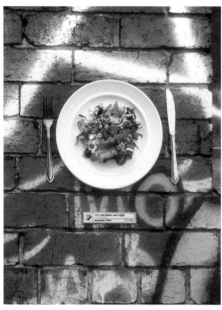

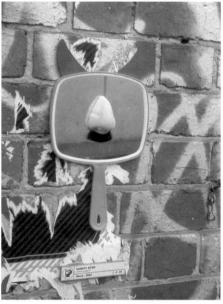

Above (clockwise from top left):
Toy Soldiers are Yum, Melbourne, 2001;
Vanity Stop, Melbourne, 2003;
Welcome to the Public Gallery, Melbourne, 2004;
Call of the Lumberjack, Melbourne, 2002.

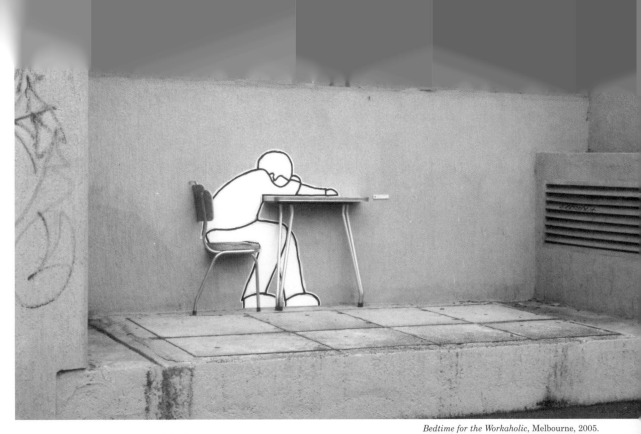

Bedtime for the Workaholic, Melbourne, 2005.

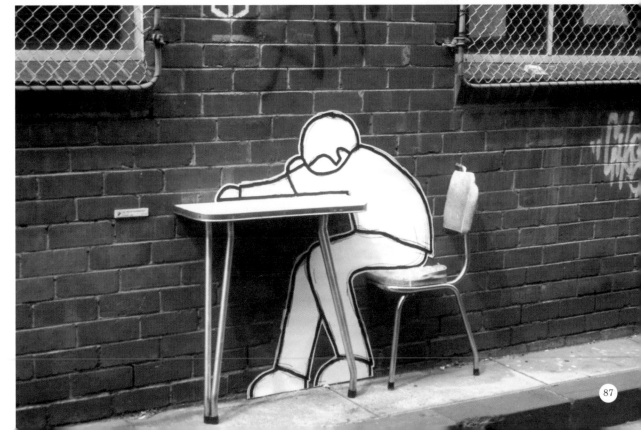

ROBIN RHODE

Graffiti and performance art are unusual things to combine, but Robin Rhode's filmed street-art installations do just that. "I started doing works on the street during high school. I just wanted attention and a creative outlet. I wanted to make a statement and to prove that art has a function," the South African artist explains. After studying fine art, Rhode became interested in how ideas of "high" art history could be fused with simple materials to communicate to a larger audience. "Mediums such as chalk or charcoal have a strong relational and economic value, so the artwork becomes more open to interpretation," he notes.

The charcoal wall drawings he creates are only one part of the work. His evolving pieces are as much about narrative as the visual aspect of making marks on walls. "Performance happened by chance," he recalls. "But at the same time it was quite natural as the scale of my drawings are usually life-size. It made sense to physically interact with and into the drawing field."

The political context of the street is also an important element to his often poetic pieces. "South Africa had a very strong resistance movement during apartheid when most contemporary art was seen as political. The 'street' in South Africa has a history infused with violence and protest. With the fall of apartheid I felt that I wanted this element still to exist within the context of contemporary art. But with a new understanding of where we're from and in what direction we're going," he stresses.

His "Playground" series was created on street corners in Johannesburg. "Neighbourhood playgrounds are in such poor condition. I decided to redraw playground apparatus such as swings, see-saws and merry-go-rounds, and allow children to interact with my drawings," he explains. The results, like most of his work, are closer to video pieces than graffiti. His work reflects a desire to extend a drawing's life-span away from the ephemeral into something that crosses into film and photography. The boundaries between mediums are not clear-cut. "I think the element of 'time' is far more important," Rhode notes. "At the end of the day we don't make art, we make history."

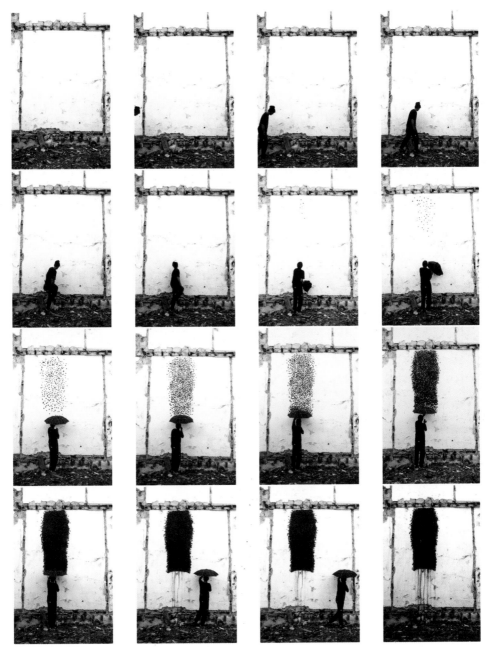

Hard Rain, 2005.
(Courtesy of the Perry Rubenstein Gallery, New York.)

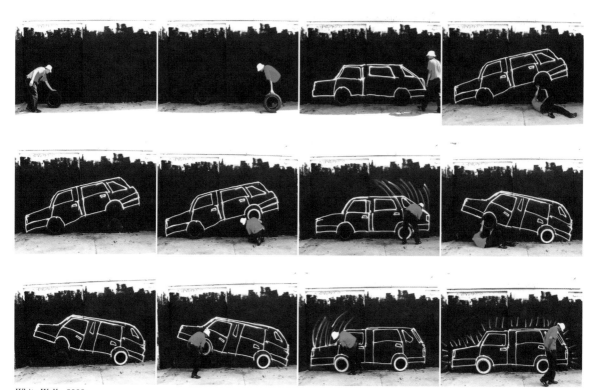

White Walls, 2002.
(Courtesy of the Perry Rubenstein Gallery, New York.)

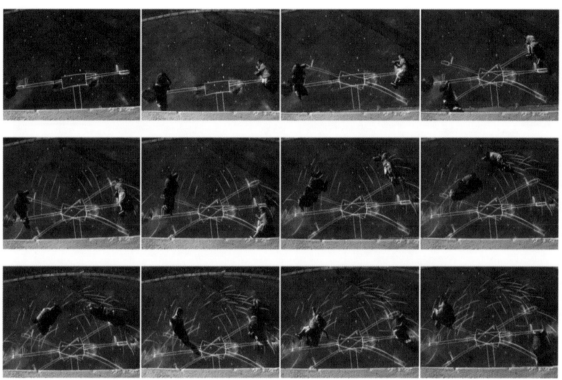

See-saw, from the "Playground" series, 2002.
(Courtesy of the Perry Rubenstein Gallery, New York.)

JORGE RODRIGUEZ-GERADA

The first thing that hits you about Jorge Rodriguez-Gerada's work is its sheer scale. In 2002, around the time he moved to Barcelona, he began to create building-sized charcoal drawings. The aim was to use the same scale, location and iconic approach as urban advertising. "I wanted to question the controls imposed on public space," Rodriguez-Gerada explains. "I wanted to question who chooses our cultural icons by replacing famous faces that sell you a product with a person picked at random that sells nothing. I also wanted to question preconceptions of where art is permitted, when art is needed and at whom it is directed."

Although he initially used ladders and scaffolding, he now creates his giant drawings with hydraulic lifts. Despite this intense effort, the results are innately ephemeral. "The blending of the charcoal and the wall surface with the wind, rain or the sudden destruction of the wall is ultimately the most important part of the process. My intent is to have identity, place and memory become one." The disintegrating urban locations he uses are equally important. These worn walls talk about displacement, gentrification, neglect and poverty. Another important aspect of the work is the documentation of the process—starting with finding each protagonist, then the act of creating the drawings and finally the chronicling of their disappearance.

These mammoth charcoal portraits weren't Rodriguez-Gerada's first foray into street art. He was a founding member of the guerrilla artist group Artfux. This collective created some of the first culture jamming billboard pieces between 1989 and 1992. Their best-known work battled the alcohol and tobacco brands that attacked the environment of the poor areas in and around New York City. "We came to the conclusion that these alcohol and tobacco ads barely showed up outside of these inner-city areas and only added to inner-city social problems," Rodriguez-Gerada recalls. After some time with splinter group Cicada Corps of Artists, Rodriguez-Gerada began to focus on his own work in 1997 "using techniques that were more metaphorical, poetic and universal," he notes. "I wanted to openly debate themes such as the sense of belonging or not belonging, the difference of being an insider or an outsider, and aspects that we use to define ourselves that may be penetrating or superficial."

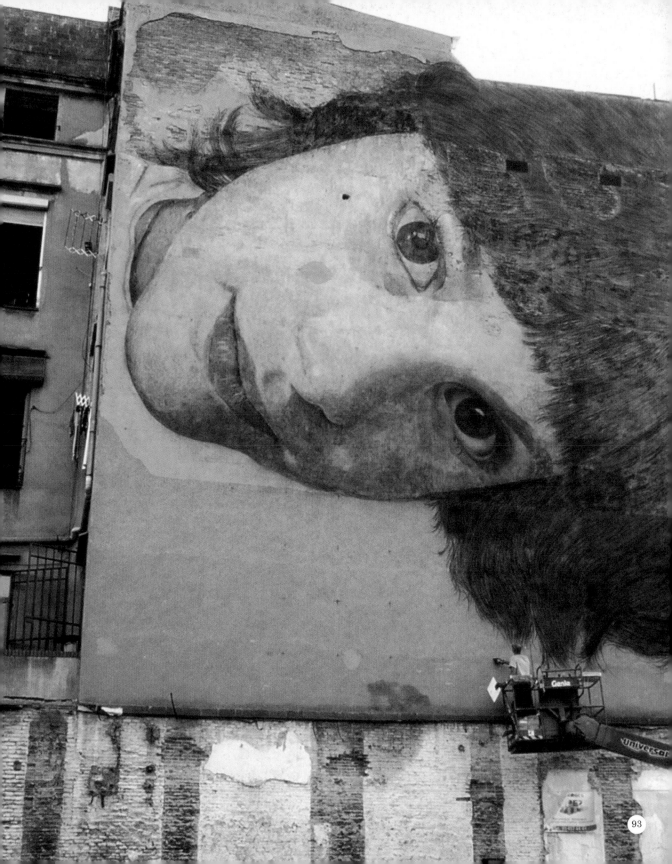

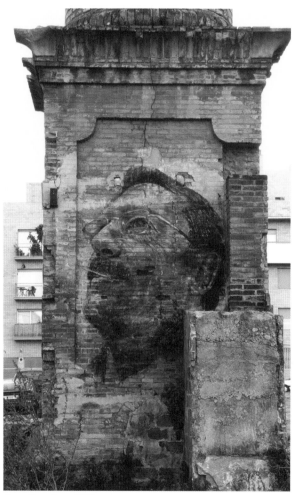

Josep, Barcelona, 2003.

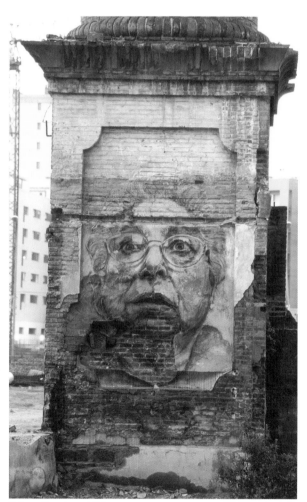

Delores, Barcelona, 2003.

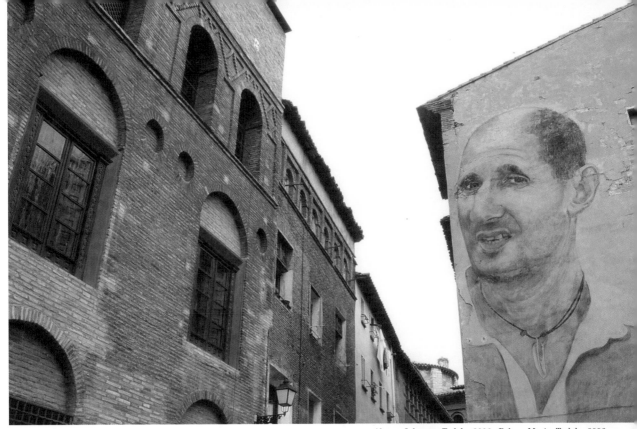

Above: *Jabonero*, Tudela, 2006. Below: *Maria*, Tudela, 2006.

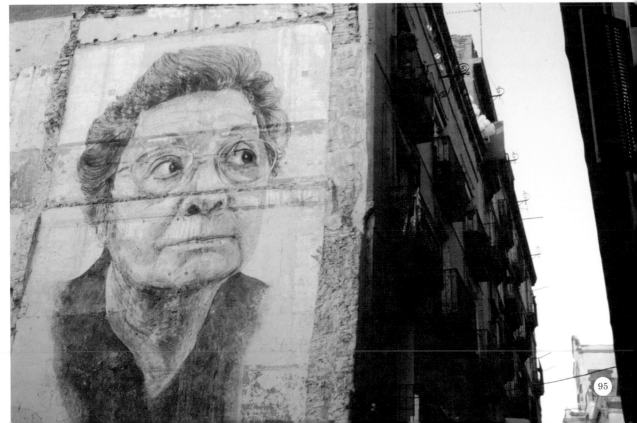

SKULLPHONE

Skullphone's monochrome pieces usually take the form of classic wheat-pasted posters. What marks his pieces out are their imagery and black humour. His work revolves around the central image of a skull with a ghoulish grin holding a mobile phone. The pieces can be interpreted as reflections of modern fears about phone radiation and technology and at the same time say something wider about the darker side of the commodification of life and consumerism. "The skullphone image itself contains two aspects which are contradictory in nature—the skull and the phone. This combination creates a larger paradox, that keeps it fresh for me," the artist explains. The work is simple but it questions the basics of modern life. As the artist notes, "What are we buying? What are we eating? What are we driving? What are we consuming? What are we trashing? What are we breathing?"

The project began eight years ago, marking the end of a dark period in the artist's life. He remembers, "My brain was full like a sponge, I wrung it out and Skullphone was born." He originally began placing stickers around cities that played with signage in petrol stations, public bathrooms and parking meters. His "New York Gates and Iron Works" posters were inspired by these ambiguous pieces. He took the sticker for the company that fixes broken gates and transformed it into something else. "I lifted this sticker and placed Skullphone on the roll-up gate. It created a new level of confusion and operated as a mock ad, as if Skullphone was now a company with a specific purchasable product or service to sell." He notes dryly, "Which it has now become." Similar street projects followed for "LA Disposable" and "London Lock & Key" gate advertisements.

Skullphone is also experimenting in other mediums. "Telephones, TVs, LED screens, cars, cell phones, mass media, mass production—they all interest me. My work revolves around the idea that we are in a downward-spiralling culture, despite and possibly due to technological advancement." His webpage is a disintegrating lo-fi mix of fake advertising, moving stock-exchange information and a frantic sense of a society gone wrong. As the artist highlights in his work, "We can't get away from technology or consumerism, no matter how hard we try."

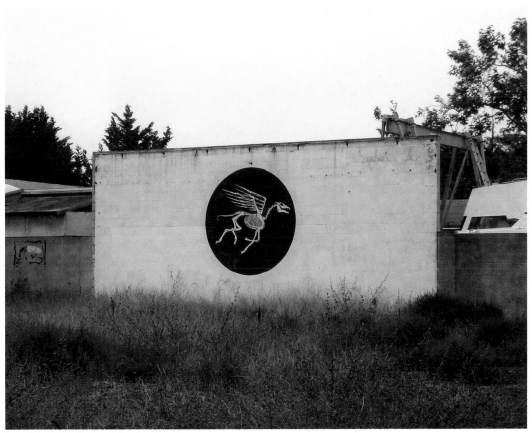

Huntington Beach, 2006.

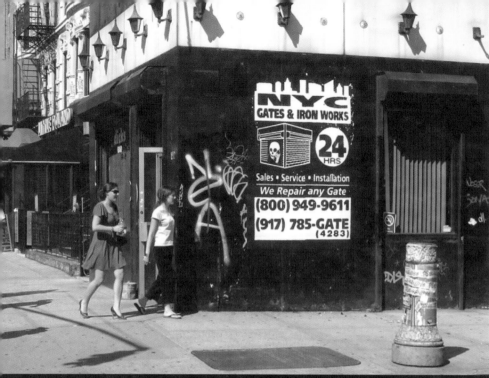

Left:
New York, 2006.
Below:
New York, 2006.

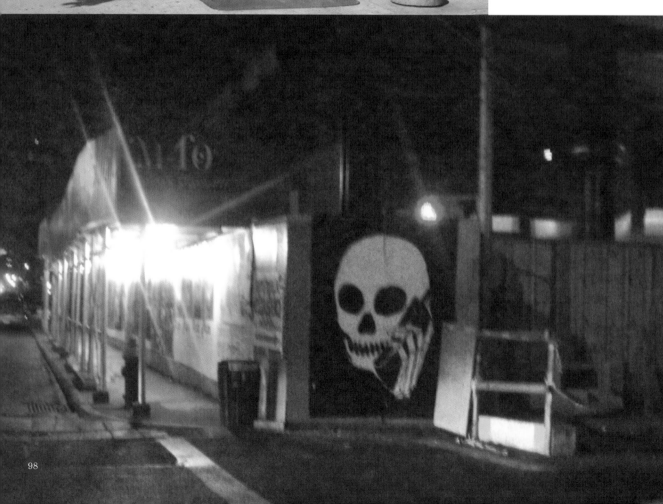

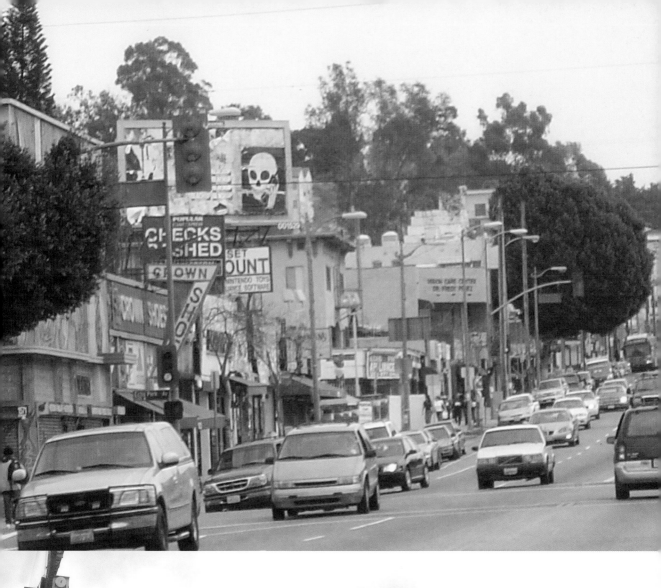

Above:
Los Angeles, 2005.
Left:
Los Angeles, 2005.

SLINKACHU

Gulliver had to go to Lilliput to feel like a giant. In Slinkachu's work the world is transformed into this two-tier universe with "reality" contrasted against small frozen moments of an alternative world. Inspired by watching a stag beetle on a doorstep, Slink decided he wanted to make something that made people look down and stare with childlike fascination. "I've always loved toys. Little people have always fascinated me." Slink notes. The way people interpret photos of his mini soap-opera-style scenes has changed how he creates his work. "I think you view my work differently if you find it than if you see pictures of it. There is a lot of symbolism in a tiny person in a giant city. London in particular can be a lonely and frightening place. I enjoy playing with those feelings," he says.

His tiny people are glued down and left on the street. Some have been found by people who know his work from his blog, "but I like to imagine that others have been found by people who don't know anything about my work, who perhaps aren't really into art or anything like that. I think that is more surprising.

I like the mystery of it," he muses. The pieces are usually planned in advance, though Slinkachu carries models around with him just in case.

They interact with the space around them in different ways. Slinkachu uses puddles and water caught in drains as backdrops for his scenarios. The drama in the set-ups of the tiny characters reflects a wider urban experience and the annoyances of city life—from London's grime to Amsterdam's red-light district. The sense of narrative strongly reflects his admiration for Edward Hopper's atmospheric urban paintings, fused with the stillness of Ron Mueck's models and a dose of street invention. The humour in the work prevents it from becoming too negative. "I love the way that street art can surprise people. It catches people where they least expect it and jolts them out of their everyday lives. I love conventional art too, but you expect to be surprised and entertained in a gallery (although whether you always are is debatable)." Slinkachu's art may be small but its resonance is larger than life.

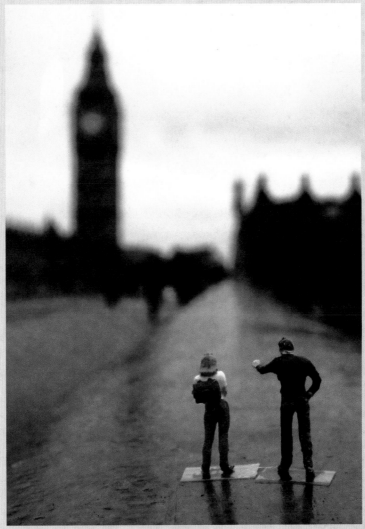

Tourists, London, 2006.

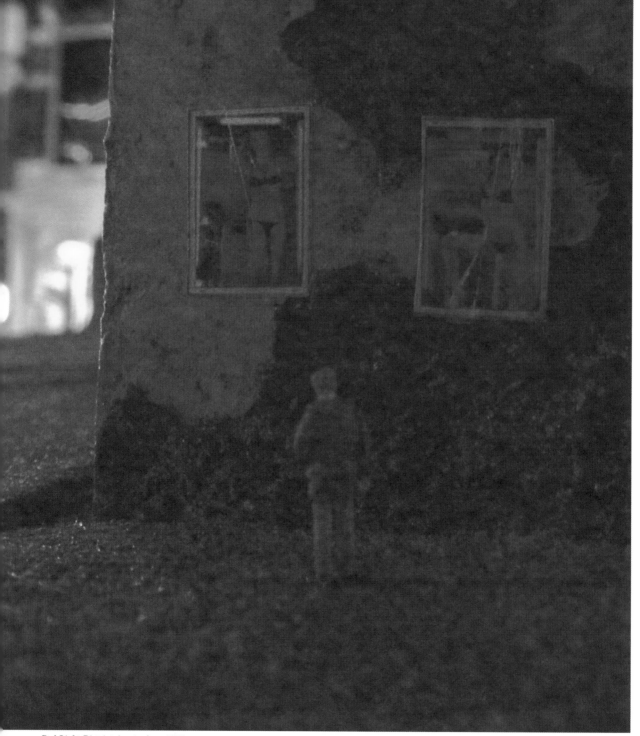

Red Light District, Amsterdam, 2006.

Opposite:
Manhole Swimming (close-up and context), London, 2006;
Dealer (context and close-up), London, 2006.

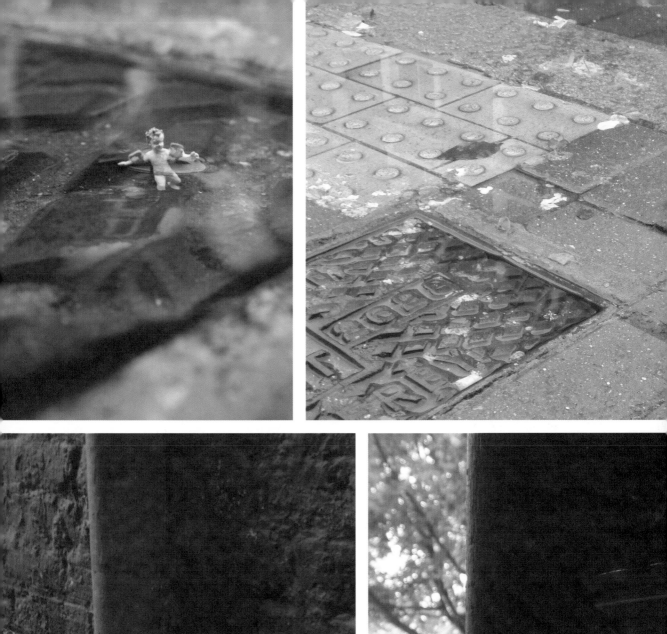
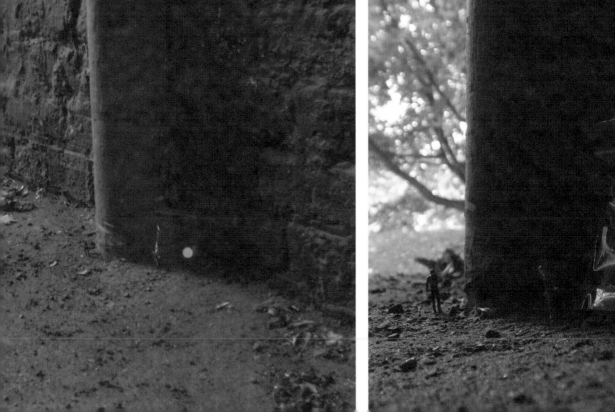

JUDITH SUPINE

There's only one word to sum up Judith Supine's work: disturbing. The artist has worked in a number of varied styles from colour collages to violent drawings, to her current day-glo tinted black-and-white collage paste-ups. "I am trying to progress beyond each style so that the process continues to evolve. I am attempting to translate the visions in my head into reality. So I need to invent new methods and techniques," the artist expounds. What holds the work together is an uncomfortable use of juxtaposed images taken from some very odd magazines including 1960s *Seventeen* magazine and military boarding school yearbooks to the 'Encyclopaedia of Adult Relationships'. Supine began by cutting and tearing pages from magazines found in her neighbourhood's rubbish. "One neighbour in particular had lots of unusual magazines. Periodicals ranging from farm journals to feminist pornography. I started reassembling them," she recalls.

Judith Supine puts up work mostly in Brooklyn and downtown Manhattan. The pictures themselves are often very dark, incorporating pictures of soldiers, wars and devils. The juxtapositions are a conscious choice to highlight the hypocrisy of modern politics. Even the colours in Supine's work are unnerving— a little too bright, almost inhuman. "My day-job as a janitor does not pay very well. The only paint that I could afford was craft paint," she notes wryly.

The wildness of her pieces reflects the violent visual noise of the tags and graffiti of the locations where she pastes her work. These are scarred and damaged walls that reflect the grime and grit of the city. "The background I choose is another piece of the collage. I try to find a setting for these characters to sojourn," she explains. A self-confessed anarchist, Supine has no regard for property and ideas of ownership. "When I wheat-paste a poster in a public space I feel that I am expressing my right to use that space with creative intent. I feel that beauty can have a healing effect … I try to live according to a law that is higher than the law of the court. I believe in ignoring silly laws that have been put in place to protect the interest of the haves over those of the have-nots."

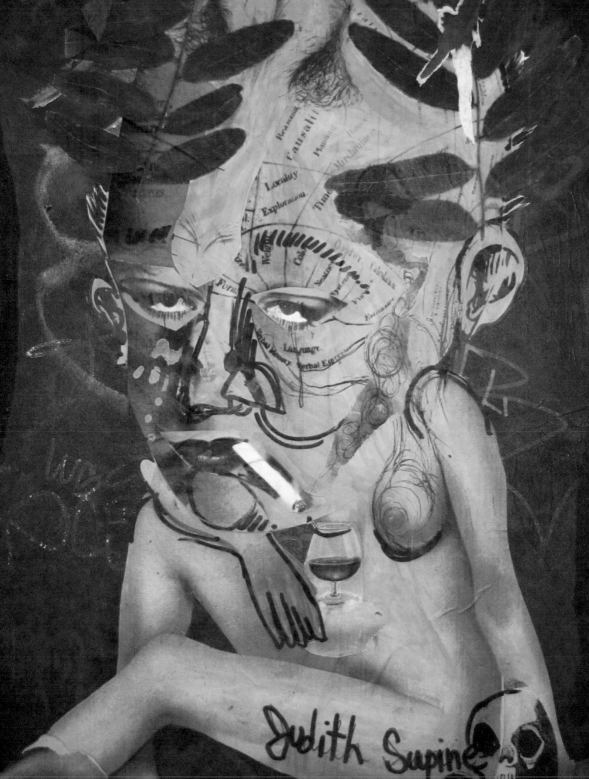

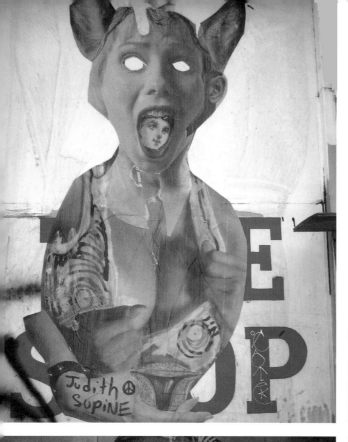
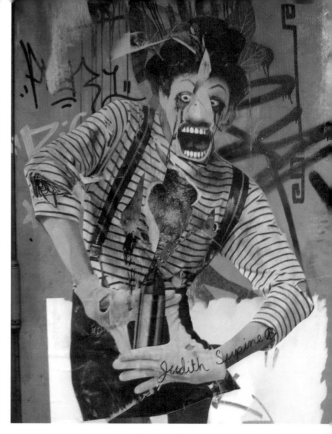
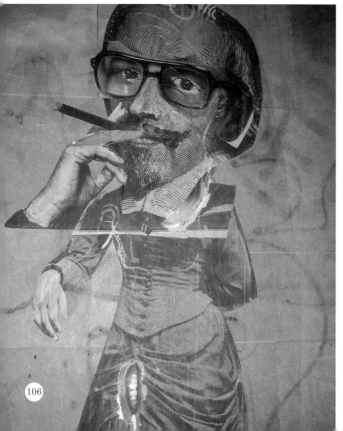
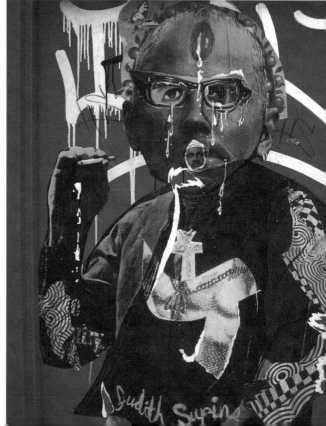

Page 105: New York, 2006.
Left: New York, 2006.
Right: New York, 2006.

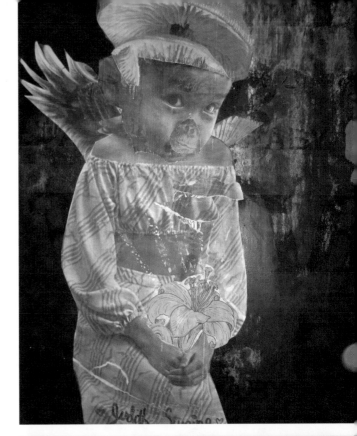

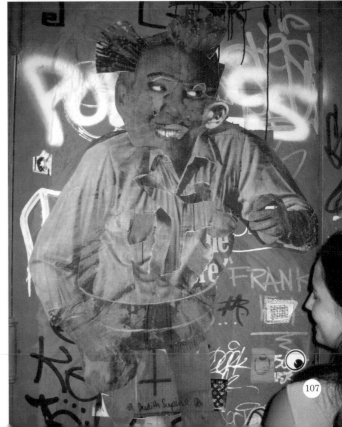

THOUGHT POLICE

In George Orwell's novel *1984*, even thinking the wrong thing is a crime worthy of death—hence the thought police on the lookout for 'thoughtcrime'. It's the ideal name for the London-based art collective. The artists Eric Pentle and Product Two are as hard to read as Orwell's characters. Their street pieces are abstract, strange and unexplained. There are no obvious elements of style throughout their pieces—rather a leftfield approach. As Product Two emphasizes, "I have an overt horror at the idea of style. It traumatizes me everyday in my own work and play—the weight and importance it is given."

Some of their street interventions are surprisingly minimal. They draw the backs of heads and place the inverse portraits on urban walls. They have placed a stuffed-clothes sculpture of a homeless person, with a black plastic bag for a head, around the streets of London. They create strange, small waxwork scenes perpendicular to walls. Their best series involves circling or squaring objects on the street with chalk. "Separating and signing something is a pretty simple idea." Pentle points out. Singling out objects gives them a sense of importance that has no obvious basis. The works create immediate questions about who and why the things are of importance, like a street version of Marcel Duchamp.

The British, urban context of the work is an important influence on their approach. "The reality is decaying, empty cities where overfed people shuffle to and fro in brand-new shoes, in patched-up nineteenth-century houses that smelt of the words 'up and coming'," Product Two points out. "Everyone is roughly content, and it shows. If we romanticize the squalor of our setting, it falls comfortably into the category in our brain, and we don't despise it any longer. Art is a religion we propagate. I'm working against you but for you," Pentle adds. "The artist's job is to manipulate history through his medium." There is something destructive about their work—even pieces that aren't visually disturbing can still be emotionally disruptive. Their pieces are like question marks dotted around urban space. "Some recent work doesn't harm anything, but I couldn't say that it is a conscious intention to get away from destruction," Pentle says. "Some things need destroying."

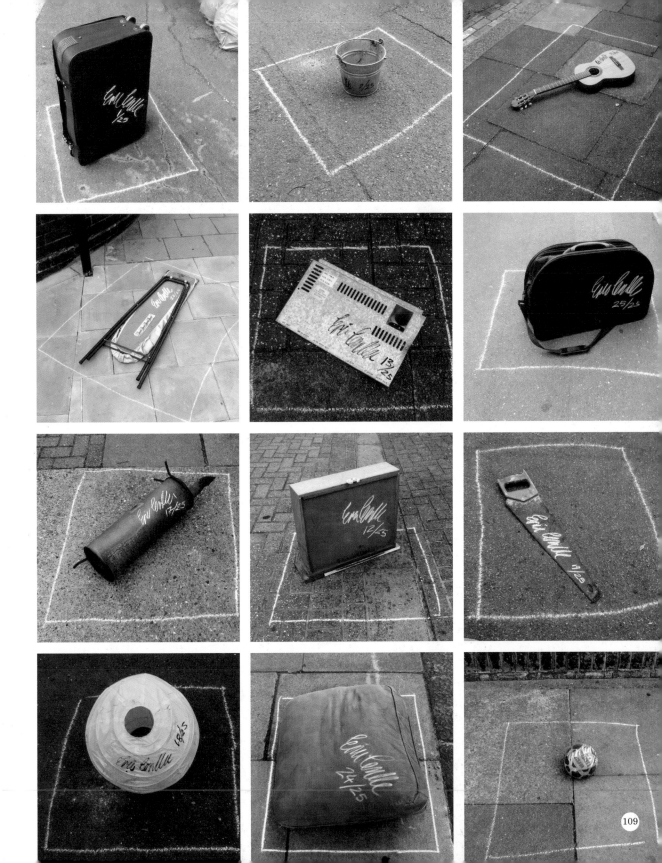

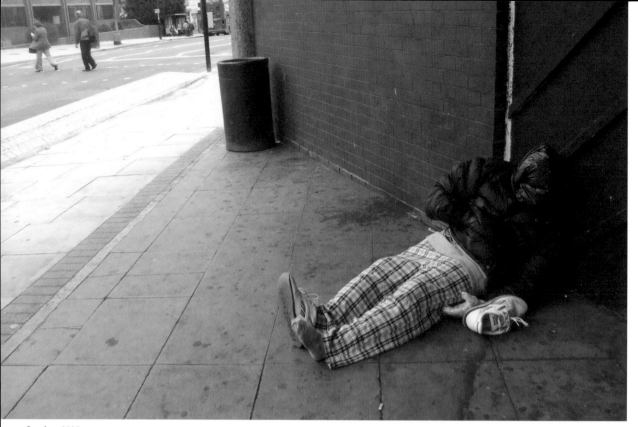

London, 2006.

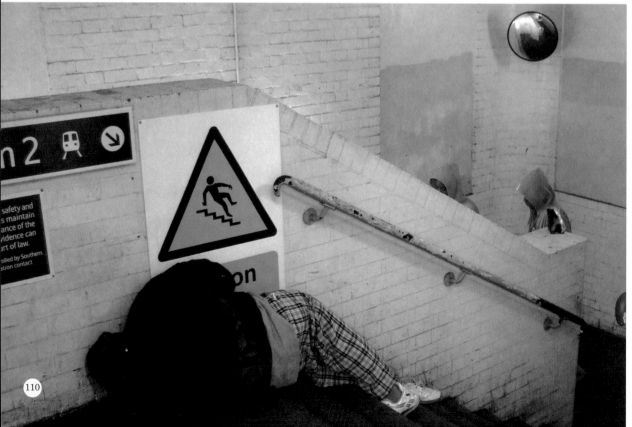

Page 109 (left to right from top):

Untitled, 1999,
chalk and object,
edition of 25.

Untitled, 1999,
chalk and object,
edition of 80.

Untitled, 1992,
chalk and object,
edition of 5.

Untitled, 2001,
chalk and object,
edition of 500.

Untitled, 1994,
chalk and object,
edition of 80.

Untitled, 1993,
chalk and object,
edition of 80.

Untitled, 1995,
chalk and object,
edition of 35.

Untitled, 2006,
chalk and object,
edition of 10.

Semi-titled, 1998,
chalk and object,
edition of 4.

Untitled, 2001,
chalk and object,
edition of 1.

Untitled 1992,
chalk and object,
edition of 25.

Untitled, 1994,
chalk and object,
edition of 13.

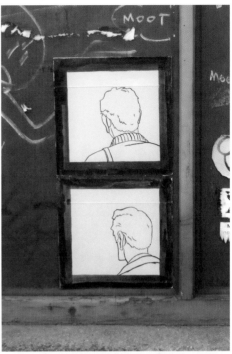

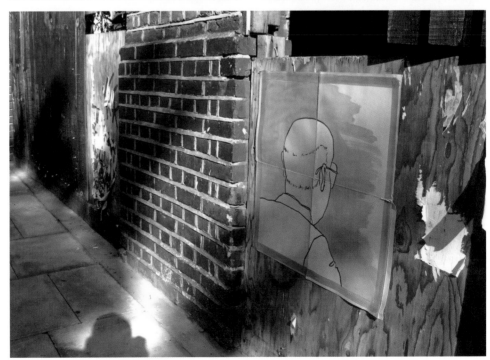

London, 2006.

THUNDERCUT

Thundercut spend their days working as freelance graphic designers and their nights sitting on each other's shoulders putting up street installations. The pair (also known as TH1 and TH2) cover the "Walk / Don't Walk" pedestrian signs across New York City with handmade vinyl images. The resulting characters play in the LED-lit boxes. "I needed an outlet which provided total creative freedom and allowed me to experiment and simply have fun. The walkers were my reaction to this need," TH1 recalls.

The "Walk" symbol of a stick man crossing the street is transformed into a plethora of characters, perforated with holes to let the light behind shine through. Thundercut's imagery includes mermaids, wrestlers, old-school break-dancers carrying ghetto blasters, girls walking their dogs, cameramen, rastas, punks, fashionistas carrying shopping bags. The signs grow to reflect the diversity of the streets themselves. "One day while coming home from work I noticed a newly installed 'walk' sign which had broken off its pole and was hanging at eye level. At the time I was working as an environmental graphic designer focusing primarily on signage so I paid particular attention to the pictogram used on the sign. I started thinking about the generic, relatively masculine 'walker' and thought it would be interesting and amusing if one of them was wearing a skirt," TH1 explains.

The pair use the electric signs to bring their works' imagery to life. "The lights are what the walkers are created around. They are the structure that defines the figure and the basis of the functionality of the sign. We like the visual play that happens when the lights light up and the walker's outfit disappears." The simple characters are always faceless. "Although the walkers are often portraits, they are not meant to represent a specific individual but more of an idea or a feeling," they explain. Coney Island walkers include an exotic dancer carrying a snake around her body and Madame Twisto, the lady with plastic limbs. The red "Stop" hand is transformed by black vinyl stickers into a heavy-metal salute near notorious rock venue CBGBs. Rather than illegality, their work aims to interact with the pace and pulse of the city and the diversity of its neighbourhoods.

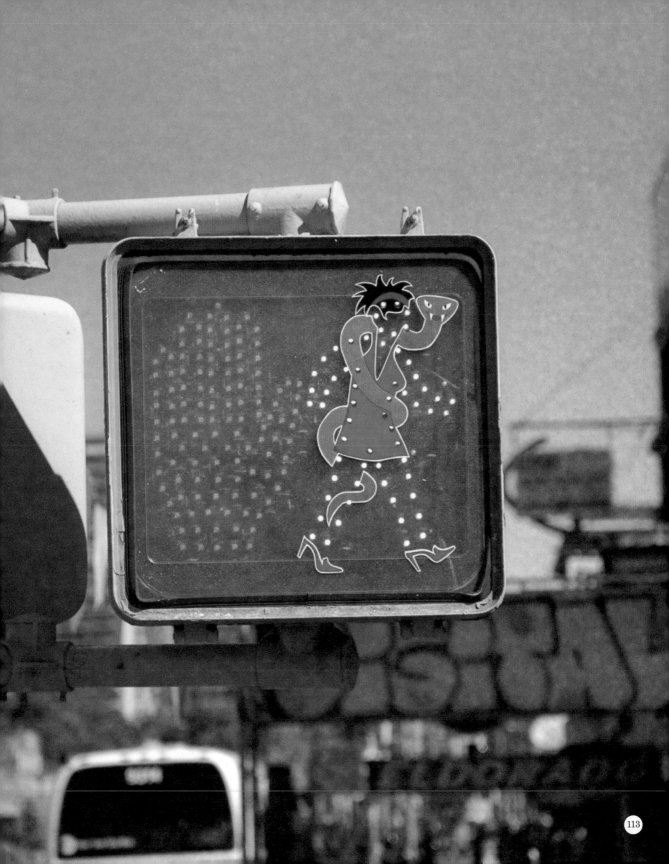

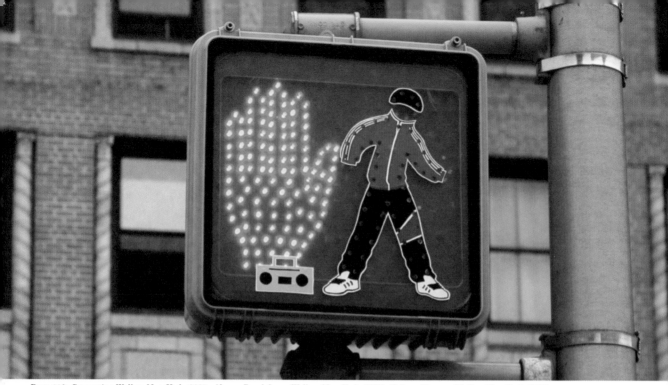

Page 113: *Serpentine Walker*, New York, 2005. Above: *Breakdance Walker*, New York, 2006. Below: *Shopper Walker*, New York, 2006.

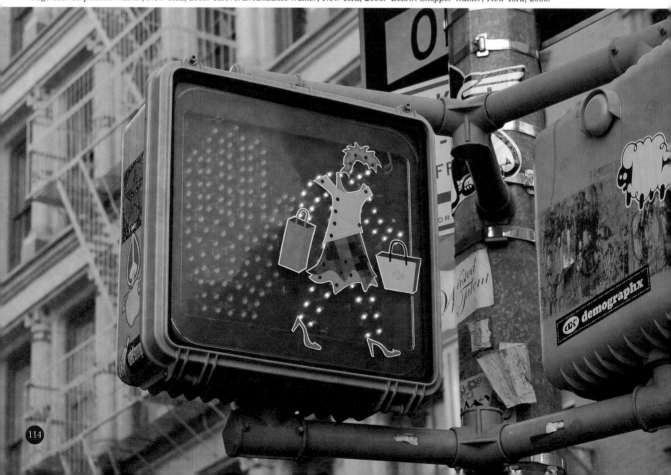

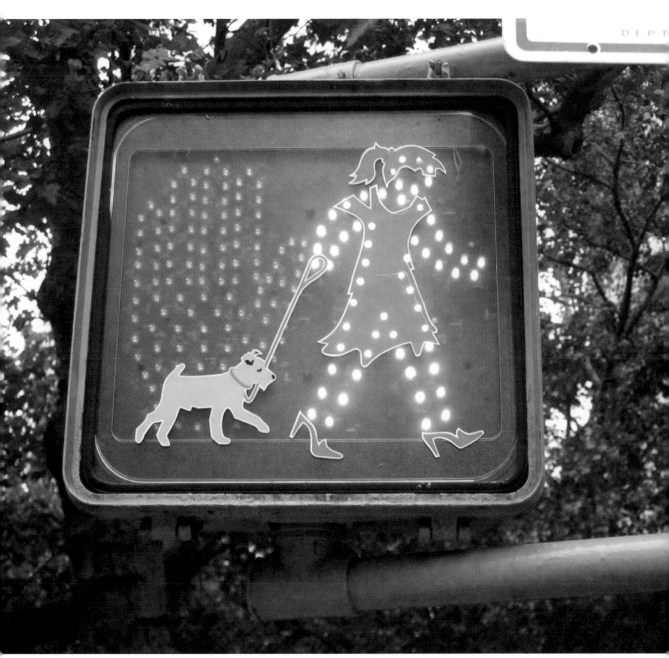

Dog Walker, New York, 2006.

TRUTH

Industrial design and graffiti make strange bedfellows. Polish artist Truth fused his training as a designer with street art. "I think in 1997 I did my first graffiti pieces but I don't count them. It was rather a sport. In 2000 I started to create on the streets as Truth more consciously and from a different point of view," he observes. His work reuses the debris of street advertisements—the wasted plexiglass, PVC and industrial materials used for street ads, signage, three-dimensional letters and logos. "My idea was to recycle and change those materials to something more valuable— art," he explains.

Truth creates three-dimensional, architectural forms that litter Poland's cities like a street version of the Russian twentieth-century painter Kazimir Malevich. These sculptures, like the paintings that inspire them, use modernist, abstract shapes and forms. "I was always interested in constructivism and minimal art, mostly because of their simple and relaxing forms. The ideas behind them are, in most cases, rather outdated. So I refreshed them with modern archi- tecture, design and a street context. It's a kind of art mash-up," he explains. The framework of the street was the only way to reinvent the modernist aesthetic, which had become almost hackneyed in gallery spaces. "Without the street context my works wouldn't exist. It's like a new life for old art. The street is fresh and full of ideas, which allows your art to reach those citizens who wouldn't normally visit a gallery."

In one series, the "Mobile Lego Project", he infused his works with humour, creating super-sized Lego street sculptures. "Everything on the streets is changing so fast. New buildings, roads, waves of people. I want to make something changeable but also some kind of a game that I can control easily. If one piece of Lego is destroyed or taken I can replace or change it with another."

Architecture is an extremely vital aspect of his work. His add-on sculptures interact and play with the buildings themselves. These clusters of cubes and rectangles grow out of the buildings like jagged crystals or mushrooms. "I treat architecture and the city as a live organism," he observes. "My works are industrial city thorns. Geometric bracket fungus growing on the walls of buildings."

Page 117:
Tired City Project,
Lido di Ostia, Italy, 2006.

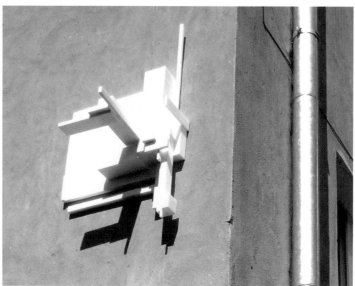

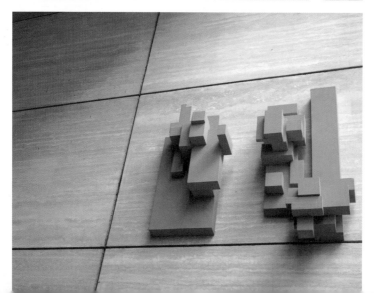

Left: all from *Tired City Project*.
Pulawy, Poland, 2006.
Wroclaw, Poland 2006.
Wroclaw, Poland 2006.

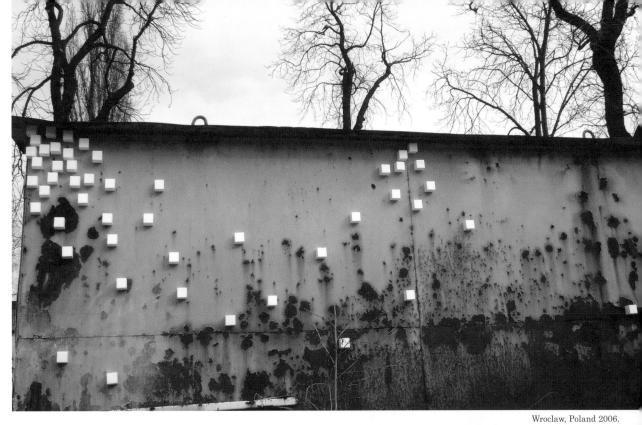

Wroclaw, Poland 2006.

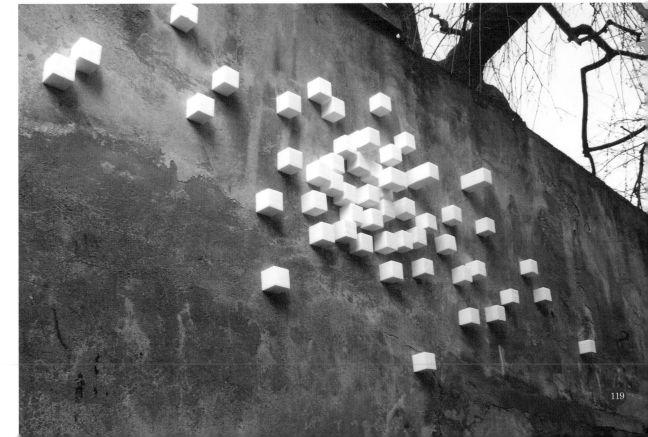

DAN WITZ

Dan Witz is the granddaddy of the street art scene. The New York-based artist has been creating work on the street since 1979. He came from a fine-art, not a graffiti, background and initially created work to rebel against the confines of the art world. "It's always been this ghetto that's not interesting to anyone outside of it," he points out. He began painting hummingbirds on rusty old walls and street doors on a casual whim. "I love hummingbirds. They flow. They adapt to their environment so you can paint them any colour." Witz enthuses. He has created something similar every year since. It took fifteen years for the world to catch up.

Witz's paintings are amazingly detailed. Objects float and fly on walls, playing with the graffiti and decay of the locations. "If you look at my work as it progresses, there is a lot of focus over what a wall means. I'll turn a wall into water. I'll have things floating on it or piercing it. I'm really interested in the formal qualities of an object on a wall," he explains. His imagery is surprisingly peaceful. His small paintings of birds, boats and chairs are the antithesis of urban chaos. "I definitely have a quieter agenda than a lot of people. I'm more anonymous. I think it's more powerful. I think it's cool when people shout but I don't—it's not my temperament." This quietness is increased when it is juxtaposed with the visually noisy, grimy walls that he is drawn to. There's a humorous vein to his work. He paints small, naked bodies on street signs and three-dimensional pieces that transform houses into faces with a well placed balloon.

The illegal aspect is crucial to his work. As the police presence has increased over the years, it has forced him to think harder about the work and how he installs it. "Whereas before it was really laissez-faire, now I design pieces that are like strategic attack," he observes. Witz's motivation has also changed over the decades. "Street art wants people to be awake. I don't really believe that anymore," he points out. "I know when artists put things up they want to keep themselves awake. That's really all I can do."

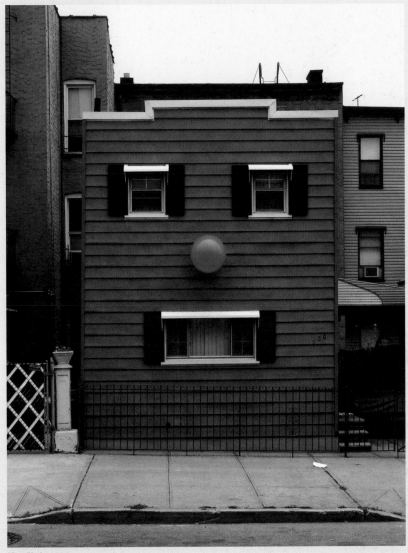

New York, 2004.

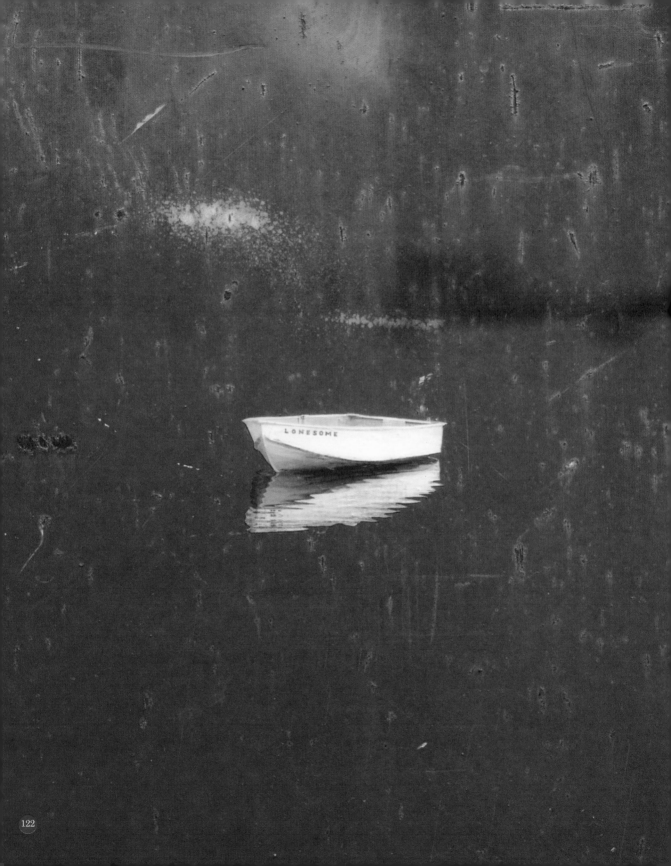

Opposite:
Lonesome Boat I,
New York, 2006.

Left:
New York, 1997;
Dumbo, New York, 1999;
From the 'Birds' series,
New York, 2000.

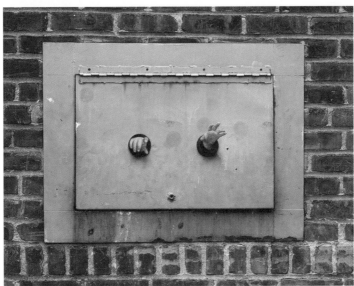

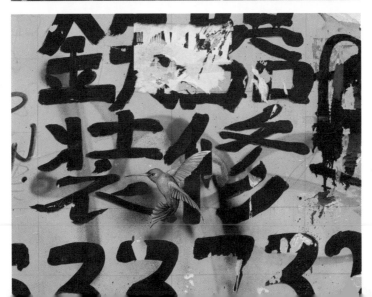

ZEZAO

It is rare that an artist consciously creates work in hard-to-find places. Brazilian painter Zezao largely makes pieces around the gutters and drains of São Paulo. He has always created work on the street and began with more traditional graffiti. His current painted wall and floor graphics still reflect the influence of spray-can art, but he has taken it in an unusual direction. His vibrant blue works grew out of text pieces and, like most Brazilian street art, are created using latex paint and rollers with a little spray paint for the highlighted details. His paintings have a sense of fluidity to them. Splashes of blue paint seem to shine out of the grime-encrusted rusty spots like neon water. Although the results are atmospheric, their creation was very prosaic. "These pieces were, in reality, developed from letters writing the name 'vicio' [Portuguese for 'vice'], which was my crew's signature. Blue was the best colour to shine out against the dirty backgrounds that I usually paint on."

The illegality of street art isn't that important for Zezao's pieces. Instead, it's much more about the disintegrating urban landscape. He paints abstract, coloured, psychedelic graffiti pieces in the streets, under bridges and in abandoned places. But he is attracted to the quality of the filth, and the shafts of light that come down from manholes onto the sewers below for his blue watery works. His paintings gleam out of darkness, bringing attention to a side of the city ignored and forgotten. He calls them the "sick places", though the street slang for cool, "sick", can also be taken literally. The São Paolo Zezao explores is ill and decaying. "The very uneven society we live in, and the disdain of the rich for the poor, are very moving things," he points out. Zezao's work focuses on places where man's touch is overwhelmed by urban disintegration. His work aims to make "the ugly and poor spots in the city more beautiful, while pointing to the city's problems of indifference and inequality. My influence comes mainly from the feedback I get from beggars and the homeless people that live alongside my work." A worthy audience.

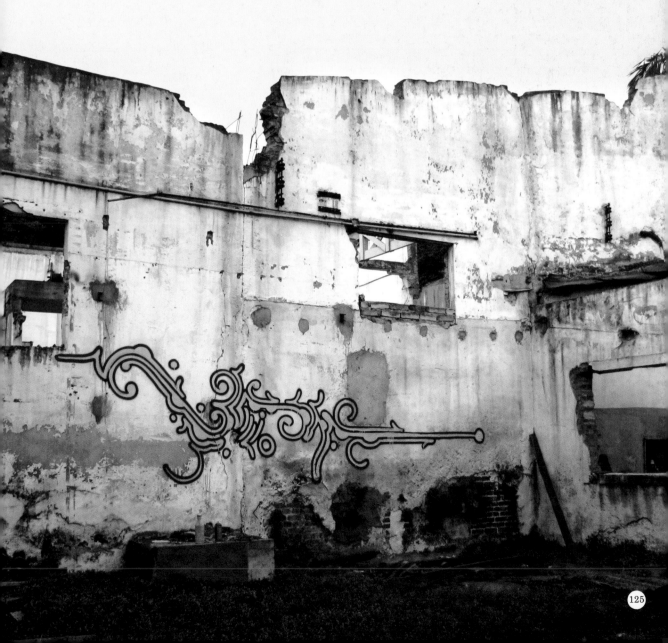

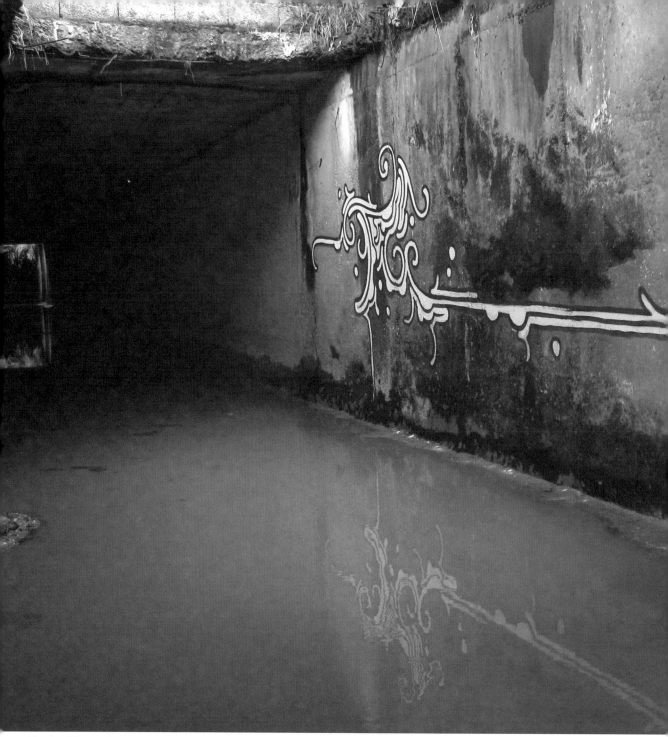

Abandoned Factory, São Paulo, 2006.

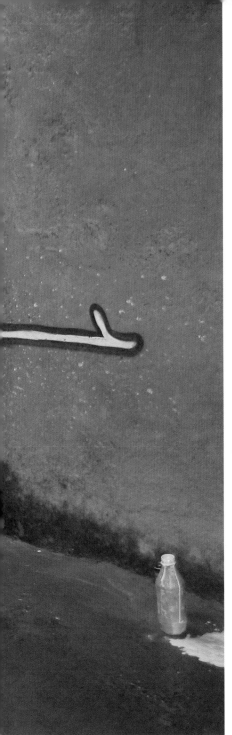

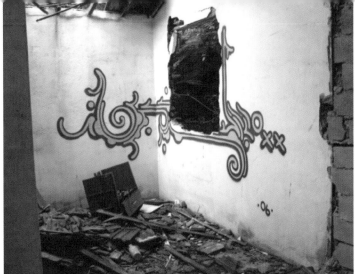

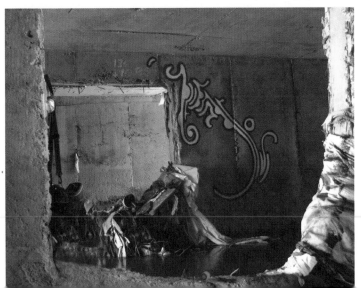

Page 125: *Sewer*, São Paulo, 2006.

Right:
Abandoned Place, São Paulo, 2006;
Sewer Door, São Paulo, 2006;
Sewer Gallery, São Paulo, 2006.

Contacts

Brad Downey	bigtimebrad@gmail.com; www.braddowney.com
CutUp	cutup@hotmail.co.uk; www.seventeengallery.com/
Eine	www.picturesonwalls.com
Eltono	www.eltono.com
Faile	www.faile.net
Cayetano Ferrer	www.cayetanoferrer.com
Samuel Francois	www.samuelfrancois.com
G*	www.flickr.com/photos/gwork/
Michael Genovese	www.genovesestudios.com
Jorge Rodriguez-Gerada	www.artjammer.com
Graffiti Research Lab	www.graffitiresearchlab.com
Influenza	http://flu01.com
Invader	www.space-invaders.com
Mark Jenkins	http://xmarkjenkinsx.com
Leopold Kessler	www.lombard-freid.com
Knitta	www.knittaplease.com
Adam Neate	www.adamneate.co.uk
On_Ly	www.onlypro.net
Part2ism	www.part-2.net
Psalm	psalmgraphics@hotmail.com
Robin Rhode	www.perryrubenstein.com
Skullphone	www.skullphone.com
Slinkachu	http://little-people.blogspot.com/
Judith Supine	www.flickr.com/photos/judithsupine
The Thought Police	www.fotolog.com/thought_police
Thundercut	www.thundercut.com
Truth	http://truthtag.com/rea.html
Dan Witz	www.danwitzstreetart.com/
Zezao	www.lost.art.br/zezao.htm

Picture Credits

Brad Downey photos by Tod Seelie, Ed Zipco and Julia Melin, CutUp photos courtesy of CutUp, p15 Jon Lowe; Eine photos by the artist; Eltono Politonos photos by Jorge Dominguez, other photos by Eltono, Xavier Entzmann; Faile photos by the artist; Cayetano Ferrer photos by the artist, p34 Jon Schroder and Mark Taylor; Samuel Francois photos by Claire Decet and Reno Combes; G* photos by the artist; Michael Genovese photos by the artist; Jorge Rodriguez-Gerada creative concept and execution Jorge Rodriguez-Gerada, documentation and photos Ana Alvarez-Errecalde; Graffiti Research Lab photos by the artists; Influenza photos by the artist; Invader photos by space-invaders.com, SCS; Mark Jenkins photos by the artist; Leopold Kessler photos by the artist; Knitta photos by Debbie Smail, William Anthony Photography, Andrea C. Moon, Ryan Schierling; Adam Neate photos by the artist; On_Ly photos by the artist, XLF/Valencia Spain; Part2ism photos by Part2ism; Psalm photos by the artist; Robin Rhode courtesy Perry Rubenstein Gallery, New York; Skullphone photos by the artist; Slinkachu photos by the artist; Judith Supine photos by the artist; The Thought Police © The Thought Police 2006; Thundercut photos by Thundercut, Abe Lincoln Jr; Truth photos by the artist; Dan Witz © Dan Witz; Zezao photos by the artist.

Acknowledgements

I would like to thank all the artists who took part in the book for taking the time to answer my humble questions and provide images. For their help Paul Pieroni, Paola Gavin, Harry Burden and Helen Evans. This book is dedicated to my sister and muse Seana, who first inspired me to look at some crumbling walls, worn out stencils and the oddities in the city I live in.
Francesca Gavin, 2007.